Taking Tea with Mackintosh

The Story of
Miss Cranston's Tea Rooms

Perilla Kinchin

Pomegranate
SAN FRANCISCO

To my parents, George and Barbara Kinchin

Published by Pomegranate Communications, Inc.
Box 6099, Rohnert Park, CA 94927

Pomegranate Europe Ltd.
Fullbridge House, Fullbridge
Maldon, Essex CM9 4LE, England

Pomegranate Catalog No. A507
ISBN 0-7649-0692-5

Library of Congress Cataloging-in-Publication Data

Kinchin, Perilla, 1951–
 Taking tea with Mackintosh : the story of
Miss Cranton's tea rooms / Perilla Kinchin.
 p. cm.
 Includes bibliographical references and index.
 ISBN 0-7649-0692-5 (alk. paper)
 1. Tearooms—Decoration—Scotland—
Glasgow. 2. Decoration and ornament—Scotland—
Glasgow—Art nouveau. 3. Cranston, Catherine,
1849–1934 Art patronage. 4. Mackintosh, Charles
Rennie, 1868–1928—Criticism and interpretation.
I. Title.
NK2195.R4K56 1998 98-7177
 CIP

Printed in Hong Kong
07 06 05 04 03 02 01 00 99 98 10 9 8 7 6 5 4 3 2 1

CONTENTS

Acknowledgments

In this little book I am drawing on work I did some time ago for my wider study of the remarkable Glasgow tea-room phenomenon, *Tea and Taste: The Glasgow Tea Rooms, 1875–1975*, and I thank again everyone who helped me so generously then. But for particular assistance with putting this book together, my warm thanks go as ever to Pamela Robertson and Daniel Robbins. I am also very grateful to Thomas and Katie Burke, Alan Crawford, Patricia Douglas, Brian Gallacher, Jolyon Hudson, Liz Irwin, and Marie Stumpf for various kind acts.

For my foray into the new field of Scottish baking, the generous help of Hugh Bradford and Bill Johnston has been indispensable. I also thank those who responded with recipes for the Mackintoshes' sand cake—all different!—and other traditional bakery: Sarah Cameron, Robert Davidson, Pamela Donohue, Daniel Giffen, Mrs. I. Hogg, Morna MacCusbic, Efric McNeil, Brenda Mowat, Noreen Reid, Kate Simpson, and Margaret Wimpenny.

P.K.M.K.

Taking Tea with Mackintosh

The Story of
Miss Cranston's Tea Rooms

A Partnership Begins

A little over a century ago, in 1897, a strikingly decorated builder's barricade was removed from in front of a new building on Glasgow's most prestigious shopping street, and Miss Cranston's Buchanan Street tea rooms were revealed to an expectant public. This was her third establishment and by far the best to date.

It was their "new art" interior decor that shot Miss Cranston's rooms to notoriety—and among the interior's most startlingly novel elements were some mural decorations by a 28-year-old architect, Charles Rennie Mackintosh.

Though Mackintosh's contribution was limited, he had found in this eccentric middle-aged businesswoman his most important patron. The commission for Buchanan Street began a special relationship that was to span 20-odd years, from 1896 to 1917—the rest of Miss Cranston's business life, and practically the whole of Mackintosh's creative life as a designer. It was a connection that gave him a thread of support through good times and bad, that produced from him a long stream of creativity, that offered the ideal showcase for his exaggerated style of design.

For Miss Cranston, her discovery marked the start of a new era that made her a household name and saw the continuous expansion of her tea-room empire. Together she and Mackintosh introduced thousands of ordinary people to a direct experience of avant-garde design, touching their lives with "difference," putting middle-class

1. The builder's barricade outside Miss Cranston's new Buchanan Street tea rooms in 1896, innovatively decorated by George Walton as a striking advertisement for the "new art" within. George Walton Archive, London

2. Kate Cranston, in the eccentrically old-fashioned style of dress she made her own, photographed by Annan, probably in the late 1890s. T. & R. Annan & Sons, Glasgow

3. Opposite: Charles Rennie Mackintosh, dressed as an artist, photographed by J. C. Annan in 1893. T. & R. Annan & Sons, Glasgow

Glaswegian bottoms on chairs that now star in museum exhibits. It is a story of touching loyalty and the joint achievement of something special.

Two portraits by the distinguished Glasgow photographer James Craig Annan introduce us to these singular partners. Some time in 1893 Mackintosh presented himself at the studio in floppy shirt and tie—in self-consciously artistic dress, that is. Born on June 7, 1868, the son of a respectable-working-class policeman, Mackintosh began an architectural pupilage at the age of 16 and in 1889 joined the practice of Honeyman & Keppie. He had attended evening classes at the Glasgow School of Art for some time and his quite outstanding drawing ability had come to the notice of the school's progressive head, Francis Newbery. But something very releasing happened when, around the time he had this photograph taken, Mackintosh and his best friend from the office, Herbert McNair, fell in with a group of lively young middle-class lady students. They called themselves, with self-mocking ambition,

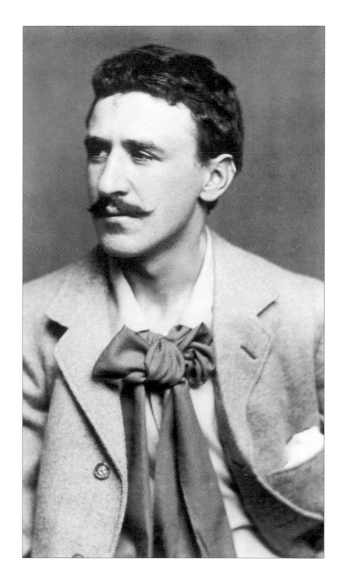

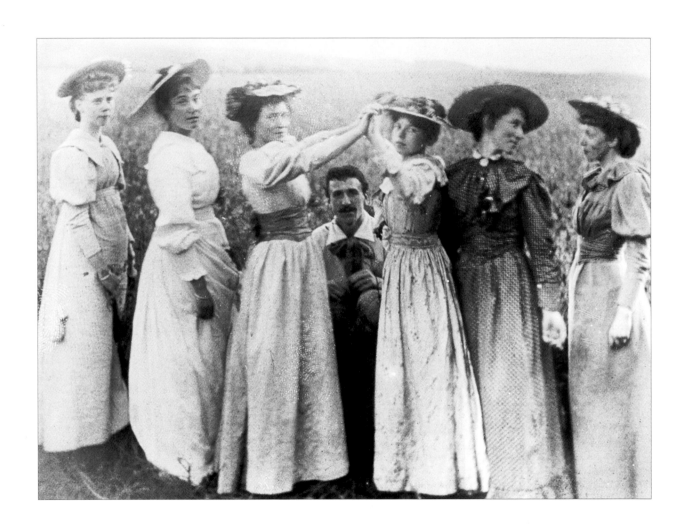

"The Immortals." They had good, silly times and produced weird art. Mackintosh, away from his draftsman's desk, was encouraged perhaps to see in "art" a path to self-fulfillment. He and Herbert were particularly strongly attracted to Margaret and Frances Macdonald. The sisters' experimental "ghoul-like," "spook-school" painting and decorative work exerted a powerful influence on the young men: they grew closer, until eventually they became known as "the Four."

Catherine (Kate) Cranston, born on May 27, 1849, was old enough to be Mackintosh's mother. In the photograph by Annan (page 8), her forthright will, her humor, and above all her individuality are strikingly evident. Someone who could dress like this in the late 1890s, indeed throughout her life, in idiosyncratic hats and the flounces fashionable in her childhood, knew her own tastes and was not afraid to flout society's norms in pursuit of them. This was not artistic dress; it was simply what she liked to wear. Miss Cranston became one of Glasgow's most cherished and widely recognized "characters," but she was respected too for her evident business capacities. People generally extended this respect to her tastes, and this is what made her such an effective champion of the new "Glasgow Style" of interior design at the end of the nineteenth century.

By 1901 Glasgow could be described as "a very Tokio for tea-rooms," and the distinctiveness of the city's tea-room phenomenon, including their prevalent "artistic" style, was firmly established. From small beginnings a quarter of a century earlier the tea rooms had proliferated to become a deeply embedded feature of Glasgow's social and business life. Although there were now many tea-room proprietors, Miss Cranston was their undisputed doyenne.

4. *"The Immortals": Mackintosh and the young ladies from the Glasgow School of Art, c. 1893. At the far right is Margaret Macdonald, whom he later married; next to her is Jessie Keppie, sister of Mackintosh's employer, with whom he apparently had a romantic understanding before he abandoned her for Margaret. Far left is Margaret's younger sister Frances, who married Mackintosh's friend Herbert McNair. Glasgow School of Art, Glasgow*

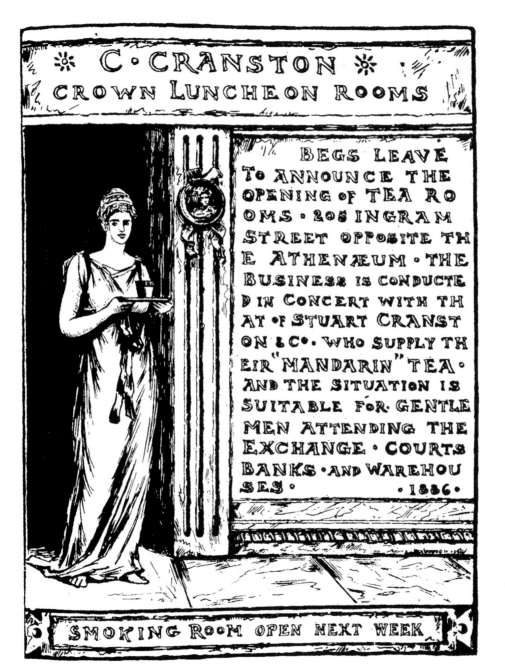

5. Advertisement in "artistic" graphic style for "C. Cranston's" new tea rooms at 205 Ingram Street in 1886. Jolyon Hudson

Miss Cranston and the First Glasgow Tea Rooms

Kate's effortless prominence was a knack that must always have infuriated her brother Stuart, for it was he who could rightly claim to have invented the tea room—one of many Glasgow "firsts." Cranston was an energetic and slightly obsessive man of entrepreneurial inclinations: he had established himself in the tea trade, in which Glasgow was a serious competitor to London at this period. With an instinct for selling to the public, he began his own retail business in 1871. Always keen to educate the palates of his customers (he was a passionate China tea man himself), he kept a kettle by him to offer samples of his blends. In 1875 he hit upon the simple idea of charging for this tasting. He provided tables for sixteen customers "elbow to elbow" at his shop at 2 Queen Street and advertised a cup of China tea "with sugar and cream, for 2d. [tuppence]—bread and cakes extra." Thus the tea room was born. While dry tea remained a cornerstone of his business, Cranston quickly recognized the possibilities of a new kind of place of public refreshment.

His younger sister spotted the potential too, and set about opening her own business in 1878. She was in her late twenties and unmarried—though not for lack of suitors, it seems. She clearly wanted to exercise her managerial capacities and was prepared to surrender normal middle-class aspirations, which dictated leisure or at best charitable work for females desiring to belong to its upper echelons. The family tradition has it that Kate paid "going-away" calls on her friends, because "they would not want to know her when she had become a businesswoman."

She was not unprepared for this step. The Cranstons had been born into the hotel business: Kate and Stuart's father, George, kept a succession of them in Glasgow's hotel heartland of the period, George Square. It was George's cousin Robert (later Bailie) Cranston of Edinburgh, founder of the famous Waverley Temperance Hotels and pioneer of this notable feature of the Scottish social scene, who financed Kate's start-up. Robert Cranston had a keen appreciation of the business talents of the women of his family, especially those of his wife and his daughter Mary, who by now ran her own temperance hotel in Glasgow and was a close friend of Kate. It was perhaps through family connections that Kate found the premises for her new "Crown Tea Rooms"—the ground floor of a temperance hotel on Argyle Street, convenient for Glasgow's commercial workers.

Miss Cranston began business in a disastrous year, when the crash of the City of Glasgow Bank brought widespread financial ruin, but the Glaswegian economy recovered quickly. In 1886 she too was ready to expand and took new quarters at 205 Ingram Street. Her advertisement (page 12) is in the mainstream "artistic" style reflected in the interior decoration. It also shows that she had her eye on the predominantly male clientele in this part of town, Glasgow's business quarter.

Those who associate tea rooms with ladies in hats taking afternoon tea might be surprised to discover that the institution developed in the first place to meet the needs of men. In this, tea rooms were a direct product of Glasgow's character as a gregarious, enterprising, self-confident business city, always open to the new. From such a context Mackintosh and all

the artistic activity of this period could also emerge.

As fashion pushed the dinner hour later, into the early evening, there arose a demand for sustenance in the middle of a lengthening working day. A Glasgow invention predating the tea rooms was the self-service sandwich bar: Lang's, opened in the middle of the nineteenth century, became one of the sights of Glasgow, and famous beyond it. Here customers, male only, helped themselves to milk, ale, whisky, and a staggering variety of sandwiches, pies, and pastries, for which they paid on an honor system that worked perfectly until the Second World War. They always stood and kept their hats on, as if to demonstrate that they were not really stopping for lunch.

The advantage that the tea rooms had over such places as Lang's, pubs, and taverns, in addition to more comfortable seating arrangements, was the respectability of being dry in an age when social life was being profoundly affected by the temperance movement. The miseries of alcohol abuse ran in tandem with industrial growth, and Glasgow, "the Workshop of the World," was also renowned as Britain's most drink-sodden city. The first temperance societies started in and around Glasgow in 1829, though it was from the north of England that the more evangelical "teetotalism" spread in the 1830s. Propaganda was directed chiefly at the working classes, but the passionate participation of many middle-class women reflected private experience of alcoholic fathers and husbands. By the 1870s, men were under strong pressure to abandon or reduce their habitual drinking.

The Cranstons, as we have seen, had strong temperance connections, and were de facto if

not paid-up abstainers, but they were not preaching temperance through their businesses. This was a large part of the success of the tea rooms, even with that influential sector of society—exemplified in Glasgow's leading weekly magazine, *The Bailie*—that put up stiff resistance to the temperance movement. The tea rooms were promoted on the more businesslike footing of convenience, pleasant surroundings, and good cheap food (the standard tea room provided light lunches and suppers as well as afternoon teas), with respectability as an added bonus.

This respectability was the key to the tea rooms' appeal to their other important customers—middle-class women. In the last quarter of the nineteenth century, women were increasingly eager to leave the seclusion of home. Tea rooms were places where ladies could respectably go alone; before this, eating out without an escort had been almost impossible. Segregated as well as "general" areas with-

in even the smallest tea rooms meant that both sexes could use them without social discomfort. Miss Cranston's Ingram Street tea room, for instance, located in the city's business area, had, as *The Bailie* noted in 1886, both a "large commodious room for gentlemen, and a neat little apartment—I should almost say arbour—for ladies," while men had another safe refuge in the basement smoking room. Women had growing spending power in this period and shopping was an increasingly attractive activity; tea rooms met the need for refreshment and "conveniences" during these outings.

The Glasgow tea rooms were feminized from an early date, largely through the influence of Miss Cranston and other female proprietors, in another distinctive respect: their decor. While restaurants characteristically hung "art"—more or less valuable depending upon the pretensions of the establishment—on their walls, tea-room art had to do with furnishing nicely.

Home decoration at this time was a key arena for the display of feminine values. Women were expected to create a haven of art and comfort that kept the dirty, dangerous world of work at bay, and a flood of books and magazines appeared around these years—the 1880s—targeting women who were desperate to know how to do it. The application of this feminine style to tea rooms introduced a new, more intimate note to the decoration of a public space. Its quality of tasteful homeliness was often remarked upon, to the disadvantage of cafés elsewhere. It had an obvious appeal to men as well as women and was enhanced by the cosseting attentions of waitresses.

In catering to both men and women, and providing both lunch and tea, the tea rooms turned naturally to Victorian domestic furnishing conventions, which differentiated areas of the home into male and female. "Dark and solid" qualities were for areas associated with men—which included the dining room, where serious eating took place—and "light and patterned" decor was for women and the drawing room with its daintier social activities like taking tea. Such conventions helped people, even if only subliminally, to know where they were, and therefore to feel more comfortable in a strange place. Mackintosh was to exploit them often in his designs.

To return to the story: in early 1888, Glasgow was preparing frenetically for its first great international exhibition. These giant displays of art and industry had been proliferating since London's Great Exhibition of 1851. It was high time for the "Second City of Empire" to declare its cultural status and industrial self-confidence by mounting one, which was to be, naturally, the largest in Britain since the London show of 1862. Thousands of visitors were expected in the city during the summer.

Miss Cranston, with an eye to an opportunity, added a lunch room at her Ingram Street premises, employing established "artistic" decorators.

She also spruced up the 10-year-old interiors at Argyle Street, and here she tried something fresher and more unconventional, commissioning the 21-year-old George Walton, who had only an amateur's track record, to do the work. He was the youngest of a large and by now rather impoverished artistic family (the best known is his older brother E. A. Walton, a leading member of the group of painters called the "Glasgow Boys"). It was probably this small commission from Miss Cranston, combined with general exhibition euphoria, that encouraged Walton to abandon his tedious job as a bank clerk and set up his own designing and decorating business in 1888. Kate Cranston had begun her career of "talent-spotting" young designers who had something a bit different to offer.

George Walton (1867–1933) is easily overshadowed by the fame of Mackintosh, but he has an important role in the tea-room story and as a pioneer of what has become known as the Glasgow Style. His was an inventive, sophisticated, and versatile talent, absorbing the English influences of the "art for art's sake" Aesthetic Movement and of William Morris and the Arts and Crafts Movement, but developing an individual style that was quite distinctively "Glasgow" and perfectly appropriate to the extended domestic context of the tea room. His outstanding contribution was the emphasis on the carefully unified interior in which one designer perfected all the details—a notion that became fundamentally important to Mackintosh.

The 1888 exhibition was an enormously successful show, which with its several "themed" cafés and restaurants established the idea of eating out for pleasure in Glasgow and set the scene for the great flowering of tea rooms. One J. Lyons, who had run the Bishop's Palace Temperance Café, perhaps took a few ideas home along with his profits—though it was not until 1894 that he began to open his famous chain of tea shops in

London, and when he did he adopted a plush French style in line with conventional restaurant taste. Meanwhile, the exhibition prompted a great leap forward in Glasgow's sense of well-being and propelled the city into its golden age.

In the boom years of the 1890s Glasgow was full of building work: more warehouses, more banks, more shops. There were more businessmen needing to network over coffee and a smoke, more clerks and shop assistants wanting their lunch or high tea, more ladies aching to rest their feet over tea and a cake. The phenomenal proliferation of tea rooms in this period shows how swiftly they met this "felt need." "A decade ago," wrote *The Evening Times* in 1895, "the tea-rooms of the city could be counted on one's fingers; now their name is legion."

The Cranstons now had many imitators, but they led the field. Stuart Cranston had opened more tea rooms, including in 1889 a large set on Buchanan Street, with confectioners' and Japanese knickknack departments alongside his loose tea retailing. After Thomas Lipton, Glasgow's great grocery entrepreneur, swept into tea in 1890, Cranston's battle—against both the spread of packaged tea and the dramatic change of taste from China to Indian tea—became fierce but hopeless. (Ninety percent of the market was held by China tea in 1870; by 1900, it had shifted to 90 percent Indian and Ceylonese.) Shrewdly consolidating his four main tea-room establishments with property acquisition, he was preparing to float his company as Cranston's Tea Rooms, Ltd., in 1896.

His sister (whose business was known as "Miss Cranston's Tea Rooms"—the names are a source of lasting confusion) had her own plans, preparing to follow Stuart to Buchanan Street. She had acquired a prime site, she had money to spend, and she intended to make her mark. Everything would be of the best.

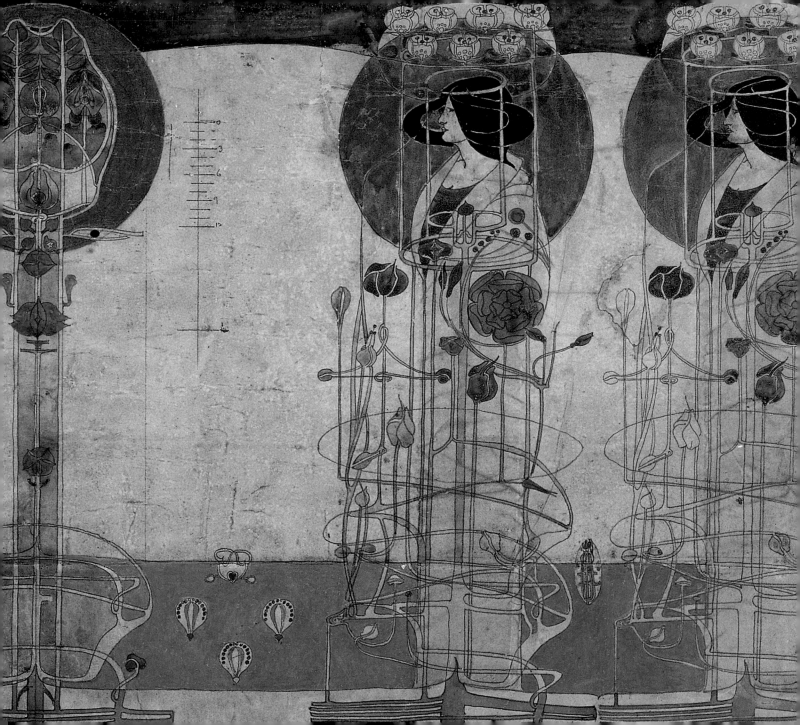

Miss Cranston Tries Out Mackintosh

Miss Cranston was by now in fact Mrs. Cochrane: she had married a prosperous industrialist, a quiet, artistically disposed but financially able man eight years her junior, in 1892. By convention, in those days marriage terminated a woman's independent career, but for Miss Cranston, typically enough, it heralded a new period of expansion, as money from John Cochrane's Barrhead engineering business was diverted into the tea rooms. Her adamant retention of her maiden name in business—though she was just as firmly Mrs. Cochrane in private—underlines both her strong sense of her own identity and the high level of recognition she had already achieved.

She planned a suite of assorted tea and luncheon rooms, with smoking and billiard rooms for men, on four floors of a brand-new building, with the kitchen in the basement. Its conventionally ornate "artistic" revivalist facade looked quite proper on Glasgow's premier shopping street. The architect was the Edinburgh-based George Washington Browne, who specialized in banks (and by a nice twist of fate, the building became a bank shortly after Miss Cranston left it).

Less conventional was the work going on inside. Miss Cranston, who had earlier used George Walton again for the decoration of her new married home, in 1896 gave him this plum job. He had started with characteristic

Detail of figure 7, the drawing for the stencil decoration of the lunch gallery at the Buchanan Street tea rooms. Hunterian Art Gallery, University of Glasgow, Mackintosh Collection, Glasgow

inventiveness by stenciling a highly effective advertisement for her and her "new art" tastes on the builder's barricade (page 6)—transforming something ordinary into something different and special. This was perhaps the earliest barricade to be given this aesthetic treatment.

Inside, Walton worked with elegance and flair around the unwelcome touches—ornate woodwork, fireplaces, and the like—left inside by the architect. Stenciled and painted wall treatments, stylish furniture, a distinctive billiard room with one of his own stunning fireplaces—he had countless details to attend to.

How Miss Cranston came to commission the inexperienced Mackintosh to decorate the walls on three floors, where they ran round a light well at the rear of the building, is not clear. Mackintosh does not seem to have been especially friendly with the somewhat reserved Walton, though they were about the same age, and it is unlikely that Walton requested this intrusion on his overall control of the interior. Perhaps Miss Cranston's nose for the

unusual is explanation enough. Mackintosh had been consorting with the Macdonald sisters at the Glasgow School of Art and sharing in the notoriety of their "grave-yard" distortions in the "new art" manner, stirred up by their contributions to exhibitions of paintings and posters in 1894 and 1895. Miss Cranston would have been attracted to these young people who dressed with panache, generally behaved like free spirits, and provoked such apoplexy in the conservative press. Francis (Fra) Newbery, dedicated to encouraging individuality at the school, had his outrageously gifted ex-students under his wing (Mackintosh was working at this time on the competition designs for what was to be one of his great architectural achievements, the School of Art itself), and he may have helped with introductions to this promising patron. In any event, Kate Cranston followed her hunch and gave this imaginative commission to a young architect who had not done anything of this sort before, though his approach was related to the recent paintings and posters that had caused such a stir.

Through the open light well, all the floors were visible, and Mackintosh took care to modulate the ground colors of his stenciled designs from green to "greyish-greenish yellow" to blue, evoking a transition from earth to sky. In the general lunch room there were peacock panels and spare stylized lollipop trees, with a vertical rhythm that complemented some elegant tall-backed chairs by Walton.

On the floor above, the ladies' luncheon room or gallery, he used statuesque white women schematically entangled with looping rose bushes and grouped with abstract tree shapes. The figures were derived from Mackintosh's recent watercolor self-consciously entitled *Part Seen, Imagined Part*. They were just the right thing, transforming an area furnished with Walton's quietly artistic rush-seated ladder-back chairs into something to talk about. The inexplicit and certainly unmentionable sexuality emanating from the tree forms, and their odd "eyes," contributed to something disconcerting and exciting in the decorative scheme.

For the masculine smoking gallery on the next floor, Mackintosh used even weirder abstract totem-pole and sun shapes and wavy "smoke" lines in a style completely at odds with the rococo flourishes left behind by the architect.

Gleeson White, editor of the influential art magazine *The Studio*, realized the novelty of these murals when he visited Glasgow in 1897 to write a piece on the new developments in design there. He praised the achievement of such effect through simple means, lambasting the "extremely irritating" interior intrusions of the architect as unnecessary eyesores. Recognizing the distinctness of Walton's work, White planned to give him a separate write-up, but he died the following year—most unfortunately for Walton's reputation. However, White's words on the stenciling suggest that Mackintosh had learned a thing or two from Walton, who had developed a distinctive technique using transparent stains and resists, exploiting the color and texture of the plaster. Walton's exceptionally refined sense of color harmonies must also have been influential.

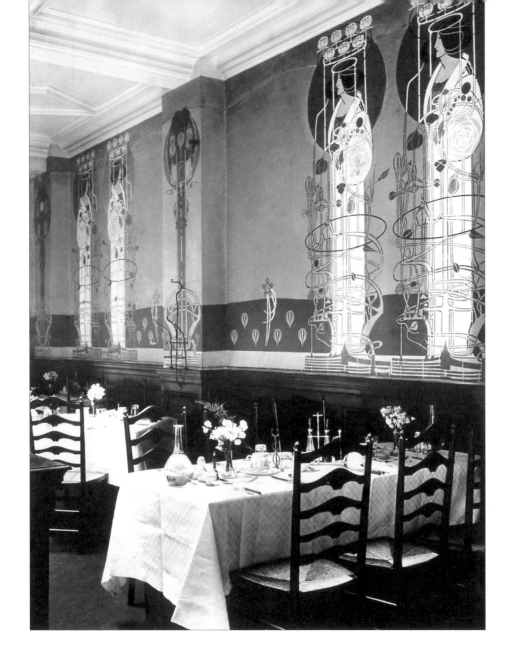

6. The lunch gallery at the
Buchanan Street tea rooms
showing Mackintosh's
bold mural stenciling and
Walton's country-style
furnishing. T. & R. Annan
& Sons, Glasgow

Like posterity, White was smitten by the obvious originality of Mackintosh and the Macdonalds and saw that they needed to be championed against critics' tendency to dismiss their work as outlandish. He pointed out to readers that time turns rebels into "the advanced but tolerated." In the case of Mackintosh he felt, rightly, that "when a man has something to say and knows how to say it, the conversion of others is usually but a question of time." Mackintosh had Miss Cranston to thank for this praise in artistic high places, and a new decorative achievement in his professional portfolio.

Conversion to the new style, at least as it was moderated through Walton's light touch, was nearly immediate. The tea rooms opened on May 5, 1897, to a chorus of approval led by that organ of Glasgow's influential classes, *The Bailie:* "Elegant as the new establishment is as seen from the street, its interior is no less elegant, the decorations being in excellent taste, and showing to much effect." The rival *St. Mungo* commented more facetiously that this latest tea room had "all the aesthetic wrinkles brought to perfection. The male attendants are clothed in vestments of soothing design, the man who works the elevator being a veritable poem. Even the spoons are fashioned upon a pattern that will thrill with ecstasy the souls of the willow-pattern and sunflower brigade" (i.e., those of an aesthetic disposition). The tea rooms won immediate "sight of the city" status: they were a place for Glaswegians to show off.

One such visitor, also impressed by the cutlery, was the English architect Edwin Lutyens, who wrote to his wife-to-be Lady Emily Lytton describing how he had been taken along to

a Miss Somebody's who is really a Mrs Somebody else. She has started a large Restaurant, all very elaborately simple on very new school High Art Lines. The result is gorgeous! and a wee bit vulgar! She has nothing but green handled knives and all is curiously painted and coloured . . . Some of the knives are purple and are put as spots of colour! It is all quite good, all just a little outré, a thing we must avoid and shall too.

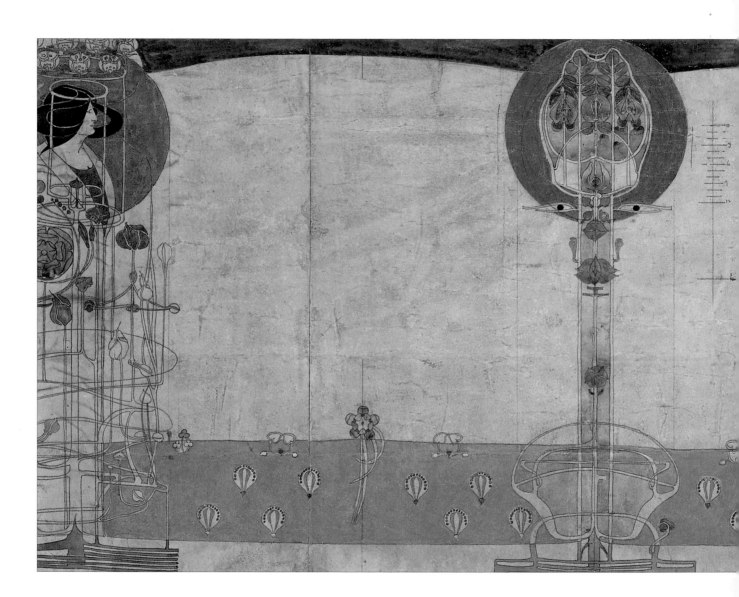

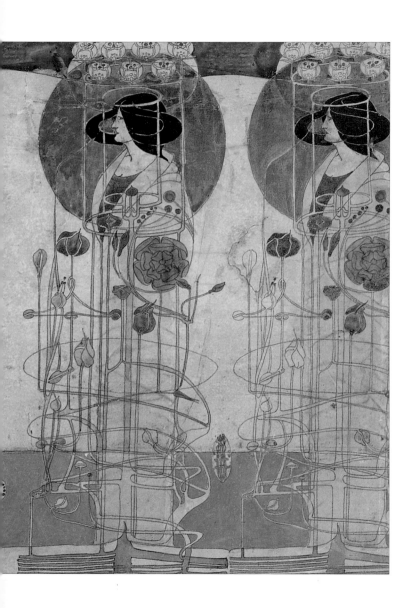

7. The drawing for the stencil decoration of the lunch gallery at the Buchanan Street tea rooms. Hunterian Art Gallery, University of Glasgow, Mackintosh Collection, Glasgow

Lutyens' language is a sensitive gauge of the ravishing effect of this slightly over-the-top Glasgow work on well-mannered English eyes. What he saw influenced the decorative designs of his new home, and despite his sniffiness, even green-handled knives later appeared on the family table. On this occasion he took home, thanks to Miss Cranston's generosity, a basket of her "most delicious blue willow pattern sets of china ware"—a special make that she used throughout her establishments— as well as a couple of beautiful clay pipes, just right for a breakfast smoke.

When Lutyens passed through Glasgow the following year, 1898, he went straight from the train to "these queer funny rooms" for a breakfast of "tea, butter, jam, toasts, baps and buns—2 sausages, 2 eggs—speak it not in Gath—all for 1/1d! so clean. Most beautiful peonies on the breakfast table . . ." Presiding over this was the indefatigable Miss Cranston, "a dark, busy, fat, wee body with black sparky luminous eyes." Lutyens sat in Walton's billiard room, which he found "all clever and original," meditating extravagantly on the influences on this Glasgow work, and concluding "So am I much amused and greatly entertained. The food! etc. at a third the cost and three times better than the ordinary hotel, and the surroundings full of space for fancy and amusement."

This is as succinct a summary as any of Miss Cranston's successful formula: good value, quality, and art. To all-around domestic excellence was added a touch of excitement, or what *St. Mungo* referred to more or less affectionately as "weirdry." It was a winning combination, and Miss Cranston and her young designers gained new consumers for the Glasgow Style among the city's affluent middle classes.

8. The billiard room at Buchanan Street, with furnishing and decoration by George Walton. Through the doorway is the smoking gallery decorated by Mackintosh, with one of the baronial intrusions left by the building's architect perched on the stair. Hunterian Art Gallery, University of Glasgow, Mackintosh Collection, Glasgow

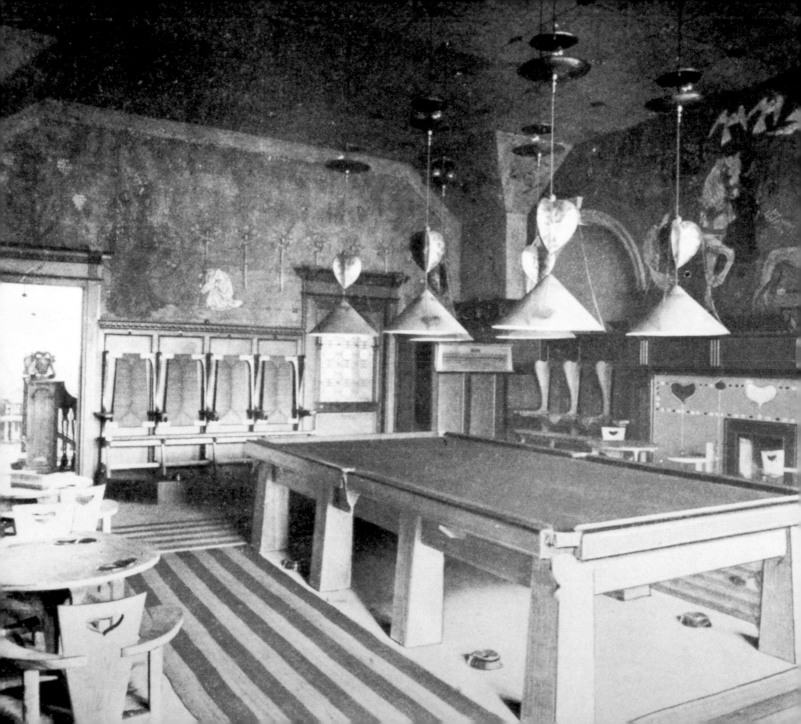

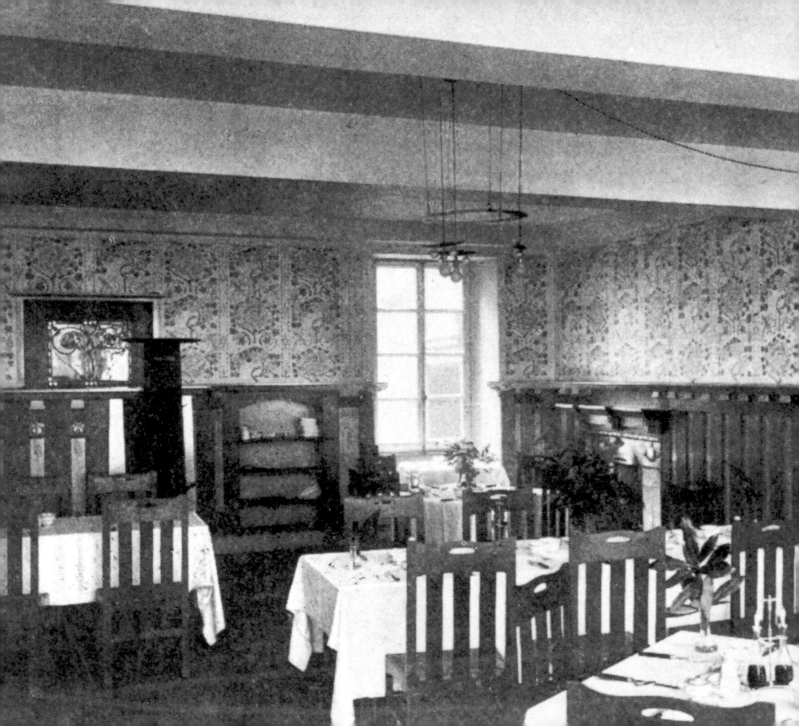

This was the height of the tea-room boom. "Anyone would judge from the number of tea-rooms sprouting everywhere that these, aesthetic or otherwise, must be profitable concerns," wrote *St. Mungo* in October 1897, when the press was full of this extraordinary change in Glasgow's social life, together with other disconcerting crazes like vegetarianism and female bicycling. In "The Spread of the Insidious Tea-room," November 17, 1897, *The Bailie* lamented the displacing of the good old "pint of bitter and a dressed steak" lunch by pastries and buckets of tea. It accused the tea rooms of turning out a new kind of roué, the clerk of artistic temperament, ruined by a mixture of tea, tobacco, talk, and pretty waitresses.

9. The end of the lunch room at the Argyle Street tea rooms, 1899, showing Mackintosh's elegantly simple chairs. Walton's fittings include pretty stenciled wall decoration using a "Glasgow rose" motif picked up in the leaded-glass panel in the door (page 32). Hunterian Art Gallery, University of Glasgow, Mackintosh Collection, Glasgow

The Cranstons were at the forefront of developments: in September 1898 Stuart opened new premises on Renfield Street. His vigorous advertising contributed greatly to the high profile of tea rooms, but lacking his sister's taste for the avant-garde, he found it difficult to keep ahead of her reputation. She kept capping his efforts at expansion. Once Buchanan Street was running smoothly she turned her attention, in 1898–9, to her next big project. She was looking to expand her empire on the site of its beginnings 20 years before, taking over the whole of the old temperance hotel on Argyle Street where she occupied the ground floor. The lease for the building is said to have been a wedding present from her husband— a nice recognition of Kate's priorities.

The architects H. & D. Barclay did a simple but thorough face-lift on the old tenement building, adding quaint gables and dormers for a "Belgian-like" effect. Perhaps after the superfluous interior flourishes of the Buchanan Street architect, their brief was to leave the inside a bare

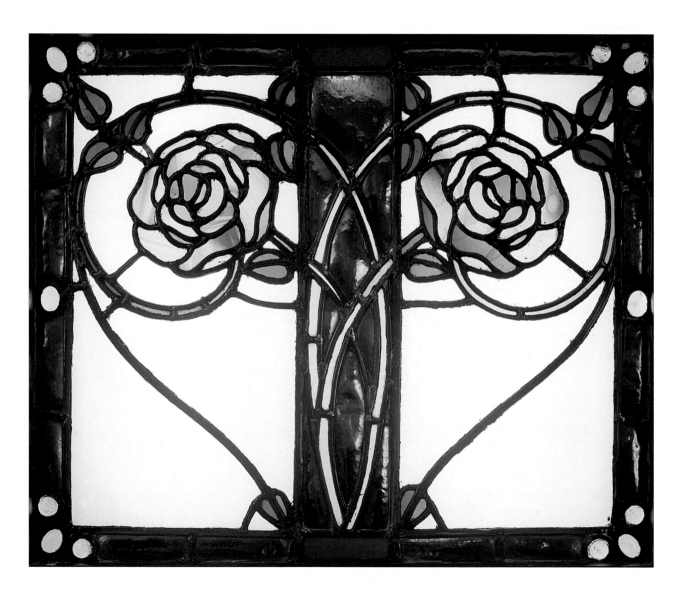

shell. The decoration and fittings were left to Walton, who thus had the opportunity to install some of his excellent fireplaces as well as the decorative leaded-glass work, enriched with copper inserts and glass jewels, that was another forte of his firm. On walls he used airy repetitive stenciled patterning, in the characteristic Glasgow Style palette of pink, green, and purple on a light background. His contribution, even in the "masculine" areas, of an element of lightness, indeed prettiness, confirmed the essentially feminine domestic style of the tea rooms. In fact, Walton was tending to break away from the dark-equals-male, light-equals-female conventions that Mackintosh would generally adhere to.

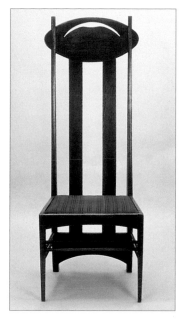

11. The high-backed chair in dark-stained oak with oval headpiece designed for the Argyle Street tea rooms, 1899. Glasgow School of Art, Glasgow

Miss Cranston was inspired this time to set Mackintosh loose on the furniture. While he had by now designed several pieces, including a suite of white furniture for a bedroom, this was a much bigger job—he produced around sixteen designs for items such as chairs, stools, and hat stands. We thus have Miss Cranston to thank for giving him a push into one of the most widely admired areas of his achievement. Indeed it was for this job that he produced his first distinctive "Mackintosh" chair.

He was using oak, the wood of choice for "artistic" Arts and Crafts–inspired furniture, and mostly he stained it dark for extra impact. A tendency to self-assertiveness is obvious: perhaps in the general

10. Panel from the door visible in the photograph of the Argyle Street tea rooms on page 30, designed by George Walton in a distinctive combination of copper and leaded glass. Glasgow Museums and Art Galleries, Glasgow

lunch room, where he used the high-backed chair, it was a response to Walton's visually strong paneling and room dividers—or perhaps it was the other way around. The problems inherent in two designers of differing temperaments trying to create a unified interior were clearer here. Mackintosh always designed furniture for particular places, to contribute to the overall effect of a room. In the lunch room, the high-backed chairs defined the space where they stood and gave a pleasant sense of private enclosure in a public place.

The high-backed chair—with an oval at its head, hovering in a glorifying way above the occupant—has deservedly become a classic. Mackintosh was obviously pleased with it: he used it in his own dining room, which can be seen in its reconstructed state at the Hunterian Art Gallery in Glasgow. The innovative construction and subtle detailing of the design are astonishing. The oval head piece, with its elegant cutout, simply slots into the side posts. Strong-looking back splats run free down to the bottom rail, bypassing the seat—

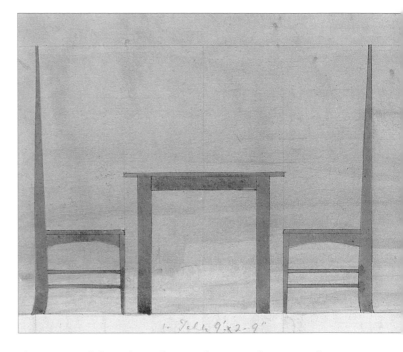

but most of them have been subsequently screwed to the seat to strengthen the structure.

Here is a problem with many of Mackintosh's chairs: they wobble. Sometimes they have been shoddily made, but more often (a serious charge against Mackintosh) they have been designed in such a way that they cannot be soundly constructed. In the search for visual impact, following

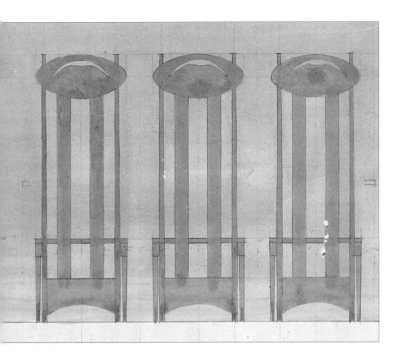

12. Design for the first of Mackintosh's famous high-backed chairs, for the Argyle Street tea rooms, 1898–9. Hunterian Art Gallery, Glasgow School of Art, Glasgow

always the new paths of his creativity, Mackintosh often discarded traditional construction. This was perhaps particularly reprehensible in the context of a tea room, where chairs needed to withstand a lot of moving around. In comparison with Walton's furniture for Buchanan Street, Mackintosh's at Argyle Street was generally unwieldy and heavy, a curse when it came to sweeping up the crumbs.

The other complaint about Mackintosh's chairs is that they are uncomfortable, but this is arguably less serious in a tea room. Dallying at the table was not good for turnover, after all, and it is important to remember that a lady of this period only needed something to perch on—posture did the rest. What Mackintosh did indubitably deliver was novelty and excitement. For ordinary Glaswegians, it was most diverting to sit on something you would never dream of having in your own house. So even if the chairs often needed first aid, Miss Cranston got something different, as she did at Buchanan Street, and this, evidently, is what she wanted.

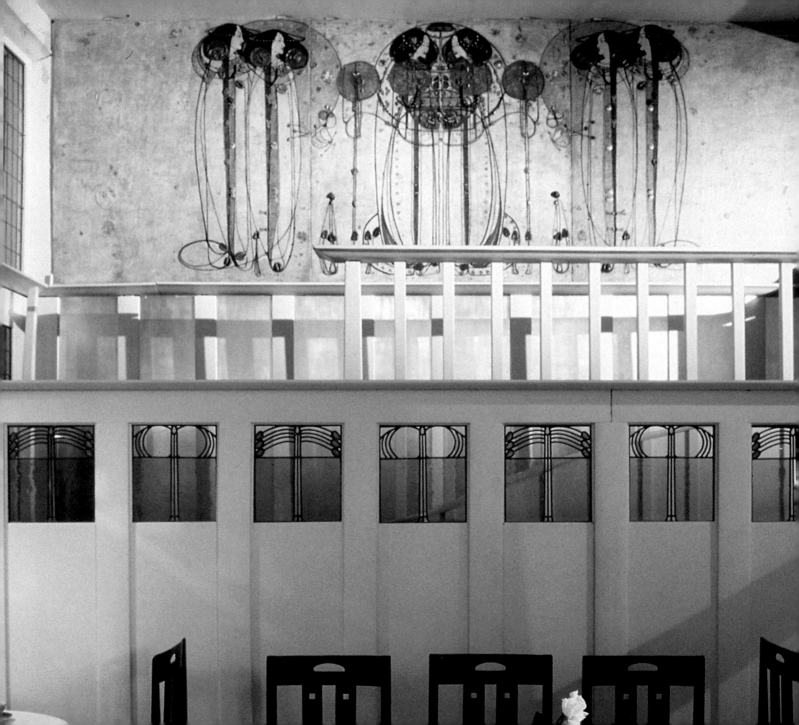

Mackintosh and Miss Macdonald

The year 1899 ended with the opening of the Argyle tea rooms and of the first phase of Mackintosh's "masterpiece," the Glasgow School of Art. Even if he did not get the recognition here that he deserved, he probably looked forward to the new century with optimism. He was planning his marriage in August 1900 to his artistic soul mate, Margaret Macdonald. Her sister Frances had married Herbert McNair the previous year, so the Four were now two couples.

Mackintosh and Margaret could not have had a better wedding present than the job that Miss Cranston gave them in 1900. She wanted a new ladies' luncheon room and a subterranean billiard room at Ingram Street, where she was expanding sideways into an old shop at 213–215, increasing her provision for women as well as men.

This time Mackintosh did not have to share anything with Walton, who was now pursuing his career in London. Instead he shared it with Margaret, and the designs emerged from the same flurry of creativity in which they furnished the flat where they would live. Their artistic union was deliberately expressed in two close pairs of decorative panels in the ladies' lunch room. Was this Miss Cranston's idea? She paid for them anyway. Mackintosh's panel, *The Wassail*, was executed in gesso, a plaster medium, embedded with string and beads. Opposite was a matching piece, *The May Queen*, by Margaret. "We are working them together and that makes the

13. The ladies' lunch room at Ingram Street showing Mackintosh's gesso panel The Wassail *above the entry passageway. The room was reconstructed by Glasgow Museums for the Mackintosh exhibition; photographed in the installation at Los Angeles County Museum of Art in 1997. Glasgow Museums and Art Galleries, Glasgow; photograph by Alan Crawford*

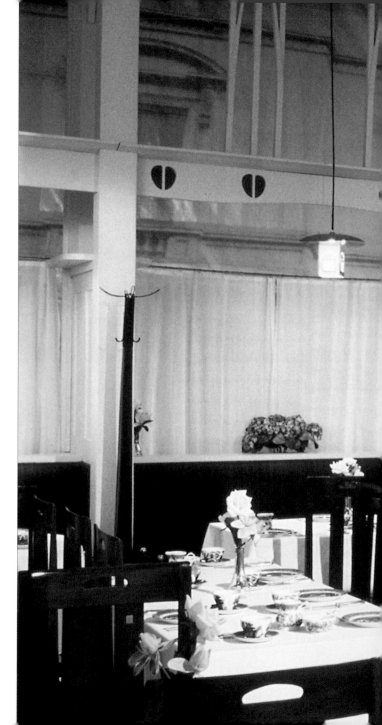

14. The ladies' luncheon room
at the Ingram Street tea rooms,
designed by Mackintosh in 1900,
as reconstructed by Glasgow
Museums in 1996 for the
Mackintosh exhibition.
Installation by Los Angeles
County Museum of Art;
photograph by Alan Crawford

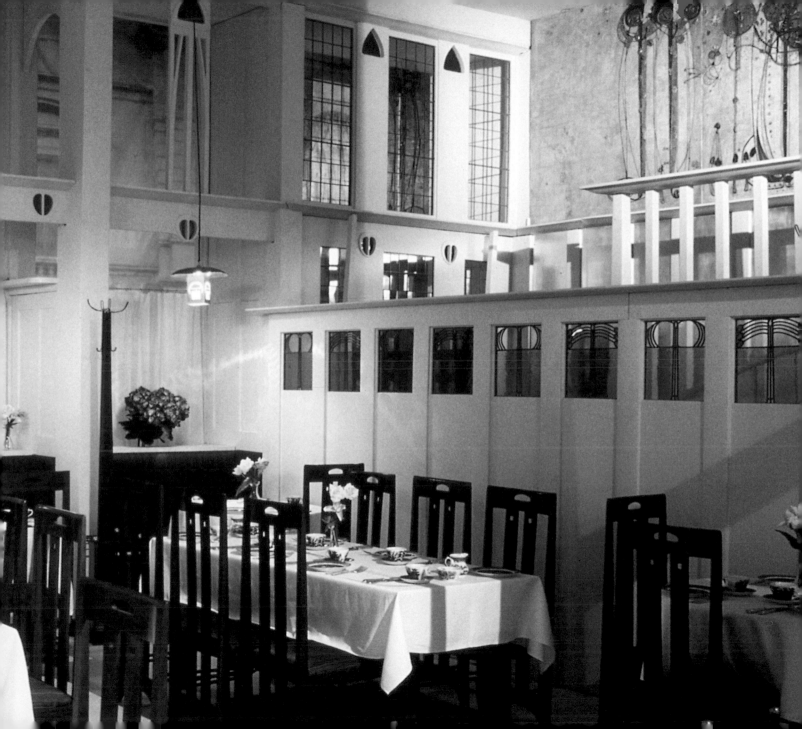

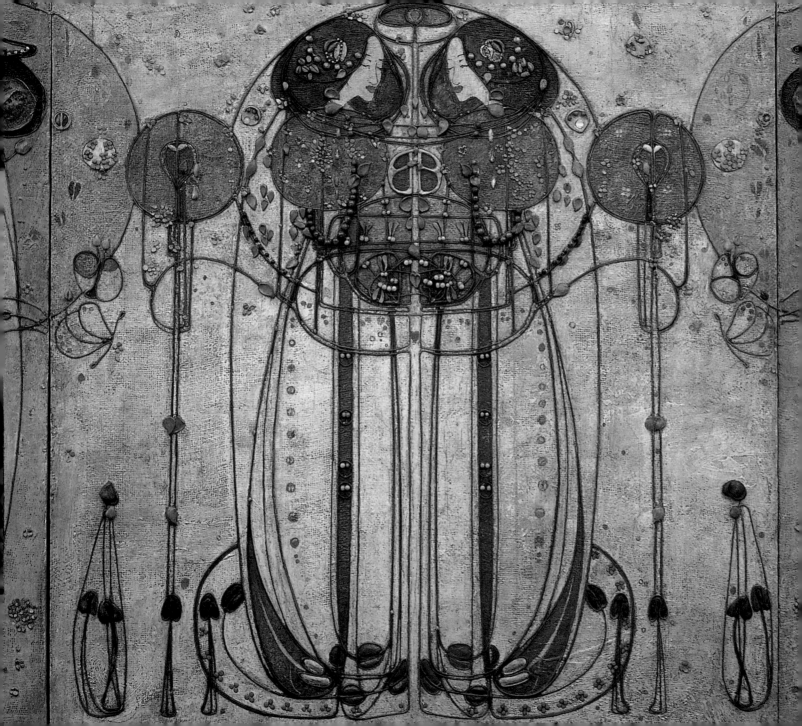

work very pleasant," Mackintosh had written to his champion Hermann Muthesius. Next to his gesso hung a small panel in silvered beaten lead by Margaret. His was opposite, next to her gesso panel.

The decorative females of these panels were no longer ghoul-like but had a contained, languid, fairy-tale quality, appropriate to this ladies' room. The creamy whiteness of the smooth paintwork and the silvery aluminum-leaf finish of the end walls came from the same domestic code (the masculine billiard room below was dark-paneled, decorated with simple stenciled squares). We must imagine stepping into this feminine haven from the grimy street outside. Full of light and gleam, with touches of pretty color in the gesso panels, the leaded glass, and the table settings, the room was a harmonious

15. Stenciled decoration from the paneling in the basement billiard room at the Ingram Street tea rooms, designed by Mackintosh in 1900. Glasgow Museums and Art Galleries, Glasgow

work of art that kept the world of commerce outside, proposing different, more spiritual values. At the same time it was a public space, and Mackintosh's elegant dark chairs minimally decorated with pierced squares seem designed to control any excess of intimacy.

Margaret had been a strong influence on Mackintosh since around 1893, especially on his interest in painting and the decorative arts, but with marriage her creativity was to a great extent pooled with his. Mackintosh's reported remark that "Margaret has genius; I have only talent" is a serious tribute. But except where she contributed specific "signed" pieces to the design jobs they worked on, her input is difficult to credit today, as with many women in such relationships. The reference is always to "Mackintosh this" and "Mackintosh that," but

Detail of figure 19, The Wassail, *1900, gesso panel by Mackintosh created for the ladies' lunch room, Ingram Street. Glasgow Museums and Art Galleries, Glasgow*

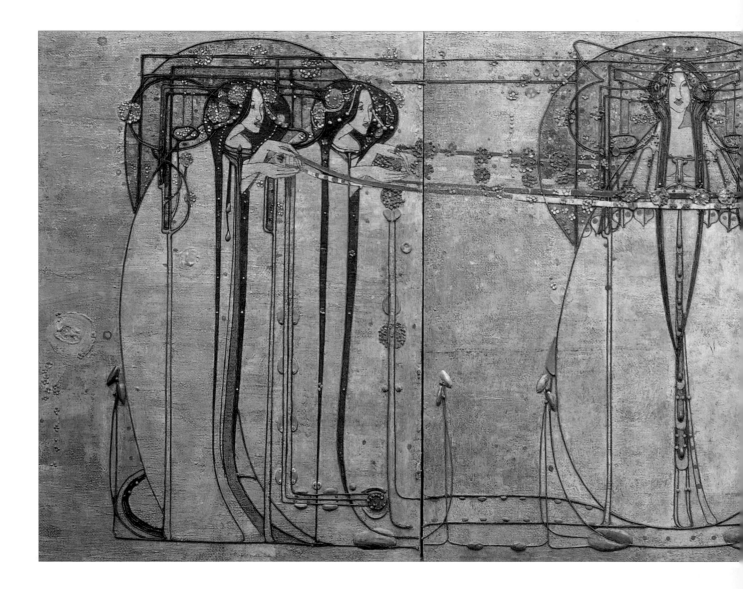

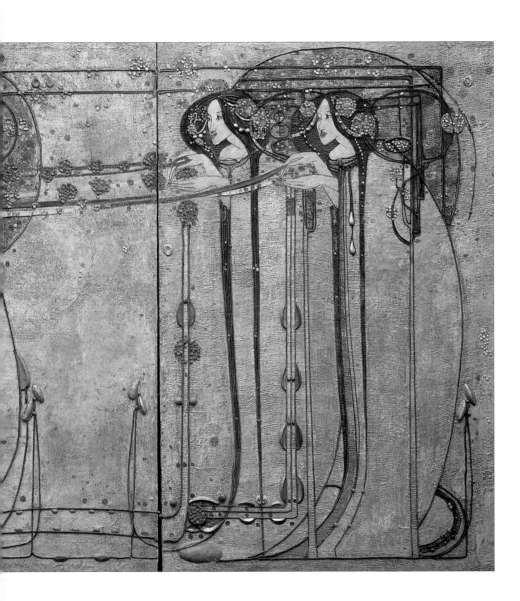

16. Gesso panel, The May Queen, *by Margaret Macdonald. It faced Mackintosh's* The Wassail *in the ladies' luncheon room. The couple worked the panels together in the year of their marriage, 1900. Glasgow Museums and Art Galleries, Glasgow*

Margaret assuredly had much to do with the development of his domestic and tea-room style, with its appropriately "feminine" qualities. However, although she has not had the credit, she has been available to take the blame, from those who want to keep Mackintosh pure and male and architectural, for what they see as decorative (that is, feminine and therefore trivial) "excesses" in his style of this period.

At Ingram Street, organic curves and petaled prettiness were in balance with retaining and counterpointing squares. Mackintosh's—the Mackintoshes'—first complete tea-room interior can be judged a success. The achievement of the effect was labor-intensive: like Walton, Mackintosh designed every detail and was involved in the execution of the decorative work. He wrote to the Muthesiuses in January that he thought the work would take three to four months; in April he described how he had been

17. Light fixture in the reconstructed ladies' luncheon room of the Ingram Street tea rooms, 1900. Collection Glasgow and Art Galleries; photograph by Alan Crawford

out at six o'clock every morning "painting the barricade"; in July he wrote, "I am not nearly done with Miss Cranston's yet it has involved a great lot of work." Miss Cranston's contribution was evidently patience and a relaxed attitude to costs. But it was ready at last in November, when the Mackintoshes took the gesso panels to Vienna to exhibit, and to revel in the accolades of the avant-garde there.

When Glasgow, in a spirit of new confidence, mounted its second great International Exhibition in 1901, it was natural that Miss Cranston should secure a presence as one of the caterers. She bagged a prime site for her "tea-house" and creeper-shaded "tea-terrace," but who designed this temporary building is unclear: nothing survives but exterior photographs and the menu card by Walton. Perhaps it was Walton: his firm still ran a business in Glasgow. Perhaps there was some undocumented input from Mackintosh.

Both were good at producing striking effects from cheap materials—like the brown wrapping paper Mackintosh used on the walls of his own dining room.

Whoever was responsible, the interior decor of Miss Cranston's exhibition tea room was certainly in what was now a recognizable style. According to Neil Munro, "Glasgow's prince of journalists," its "architectural and decorative innovations created a sensation even among continental visitors." Indeed, he records a new adjective heard at this time: "Kate Cranstonish" had passed into common Glasgow parlance "to indicate domestic novelties in buildings and decorations not otherwise easy to define." She may have garnered the credit, but she had also made her designers' work highly visible.

The 1901 exhibition was Glasgow showing off to the world, and its tea rooms were certainly something to show off. This was an area in which Glasgow was confident of superiority over the chain tea shops—mercenary chain tea shops of other cities—as writer J. J. Bell recalled in his autobio-

18. Leaded-glass panels from the screen separating the ladies' luncheon room from the entrance to the Ingram Street tea rooms, 1900. Glasgow Museums and Art Galleries, Glasgow

graphy: "I am reminded of the Londoner whom I took into Miss Cranston's first tea room. He sat down at the dainty appetising table, and exclaimed 'Good Lord!'—as well he might, poor devil, being used to nothing better than the cold marble slabs and canny methods of his London A.B.C. shops."

London was often compared to Glasgow, to the former's disadvantage. In the delightful *Glasgow in 1901*, "J. H. Muir" (a pseudonym) devotes several paragraphs to the tea room, seeing it as a distinctive, admirable, and very central feature of Glasgow life. What makes a Glaswegian in London feel he is in a foreign town, he begins, is "not the accent of the

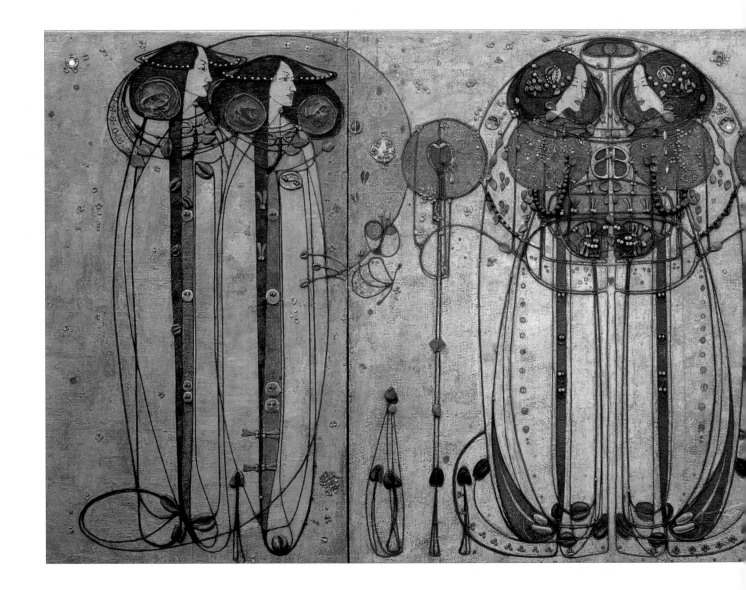

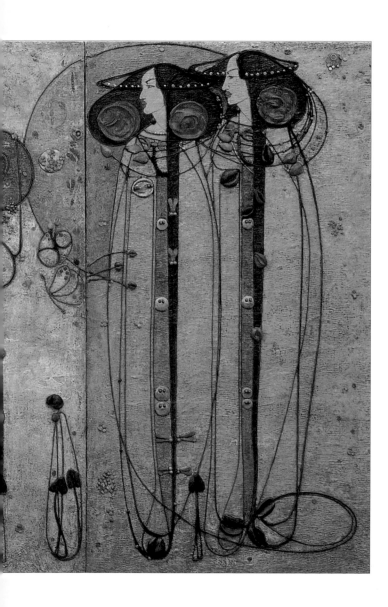

19. The Wassail, *1900, gesso panel by Mackintosh created for the ladies' lunch room, Ingram Street. Glasgow Museums and Art Galleries, Glasgow*

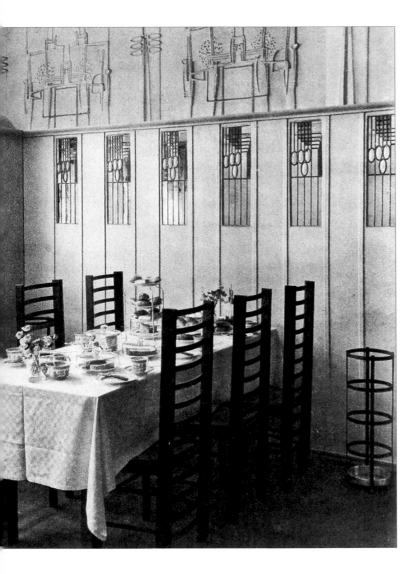

people, nor the painted houses, nor yet the absence of Highland policemen. . . . It is the lack of tea shops"; so the Clyde Scot returns gladly to a place where he may lunch for fivepence "amid surroundings that remind him of a pleasant home."

Artistic taste allied with domestic comfort was, Muir noted, a distinguishing characteristic of the typical Glasgow tea room: he hymns wooden tables, pleasantly arranged, "spread with fair white clothes and set with flowers and china." (Photographs of Miss Cranston's rooms show how the tables were set for tea, with her willow-pattern china, thin bread and butter under its glass dome, and the central cake-stand. And always fresh flowers: Miss Cranston loved flowers and often arranged

20. The ladies' tea room at the front of the Willow Tea Rooms, carefully laid for tea. Customers entered the tea rooms behind the wooden screen with its elegant leaded-glass panels. Hunterian Art Gallery, University of Glasgow, Mackintosh Collection, Glasgow

them herself.) The honor system of payment was a universal feature: "The scones and cakes, too, are there at hand, to have and to hold. Nor is one overlooked while eating, lest, peradventure, fraud might occur." You told the waitress how much you owed, were given a chit, and paid at the cash-box on departure.

But, as we have seen, the tea rooms served breakfast, lunch, and high tea, too—only a few like Stuart Cranston stuck to more limited bread and cakes. They became important meeting places, especially the smoking rooms where businessmen came for their morning coffee, a habit long believed to be crucial to wealth production in Glasgow. Every clerk had his favorite retreat where he could read the papers and play dominoes or billiards, all for the price of a twopenny coffee. The only danger was encountering his employer—for the tea rooms were in general remarkably democratic places. And then there were the attractions of the waitresses, flirtatious or maternal. The "stars" attracted followings of young admirers.

If Miss Cranston was to keep her place ahead of her many competitors, she needed to stay at the cutting edge of interior design. The quieter-mannered style of Walton had perhaps become diluted by imitation. But Mackintosh could be expected to come up with something extraordinary, which is what she had in mind for her next project. She wanted it to be her pièce de résistance.

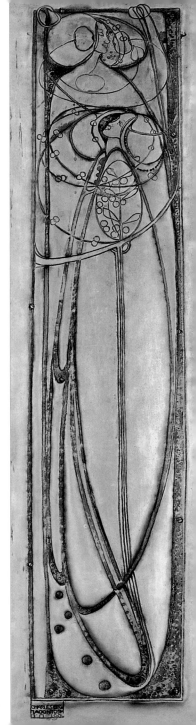

21. Silvered-lead beaten panel, worked by Mackintosh, 1900. It hung next to Margaret Macdonald's The May Queen *in the Ingram Street ladies' lunch room. Glasgow Museums and Art Galleries, Glasgow*

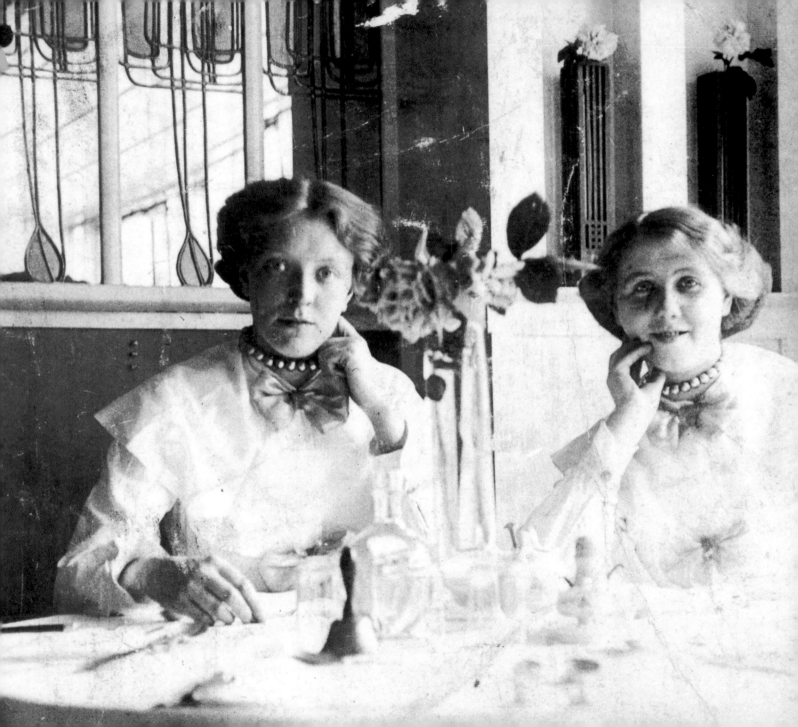

The Willow Tea Rooms

Sauchiehall Street—its name indicating, rather unpromisingly, "a damp place where willows grow"—was Glasgow's up-and-coming shopping street. Here the smartest new department stores were concentrated, attracting a clientele that was predominantly female and fashion-conscious. To stand out on this street called for some dazzle.

This time Mackintosh had charge of the whole thing, inside and out. He completely transformed the facade of the old tenement terrace building, with shallow bows, smoothly stuccoed; a variety of windows bare of moldings, some with decorative glazing; strange looping ironwork; and discreetly smart strings of squares. Its qualities of both chic and cheek are apparent today: this is the one of

Miss Cranston's tea rooms that can still be, partially, experienced.

Inside, the somewhat extravagant, intense style developed during these years by Mackintosh and Margaret struck a note quite suitable for this part of town. The opening of the Willow Tea Rooms on October 29, 1903, provoked a satisfactory level of amazement. *The Evening News* thought Miss Cranston's new establishment "the acme of originality." *The Bailie* wrote that it

fairly outshines all others in the matters of arrangement and colour. The furnishing, besides, is of the richest and most luxurious character. Indeed Miss Cranston has carried the question of comfort fairly into that of luxury, when providing for the enjoyment of her friends and patrons. Her "Salon de luxe" on

22. *Two of Miss Cranston's specially selected waitresses in the "Room de Good Looks" (Salon de Luxe). Their picturesque costumes, with chokers of pink beads, were designed by Mackintosh. Charles Rennie Mackintosh Society, Glasgow*

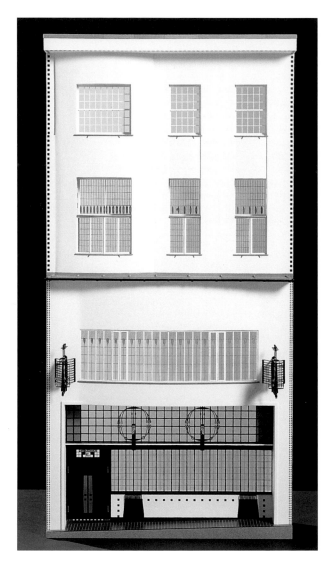

the first floor is simply a marvel of the art of the upholsterer and decorator. And not less admirable, each in its own way, are the tea-gallery, the lunch-rooms, the billiard-room, and the smoking room.

We can notice here both outright approval of the decorative designs— i.e., of the Mackin-toshes' work—and, again, the attachment of credit for it to Miss Cranston's name. This is the bind many designers find themselves in, but for Mackintosh over the years it added up to a cruel lack of recognition.
On entering, customers passed, as at Ingram Street, behind a white enameled screen inset with elegant leaded-glass panels (page 48) to a central cashier's station and a choice: into a light ladies' tea room at the front or a darker general lunch saloon at the back, or up the stairs to the tea

23. A model of the facade of the Willow Tea Rooms. Mackintosh recast an old tenement to make this brilliant little building, opened in 1903. It has been largely restored and is partially open as tea rooms. This beautiful model was made for the Mackintosh exhibition of 1996–7 by BG Models. Glasgow Museums and Art Galleries, Glasgow

gallery built around a well over the back saloon. All these spaces were interconnected—separated only lightly by ironwork screens or an odd structure with the semi-circular order desk behind it (shown on page 58). Part of the excitement of eating out is seeing and being seen, and Mackintosh allowed for this with panache. We must animate the photographs in the mind's eye with glimpses of Edwardian figures to appreciate the effect that Mackintosh's open-plan design achieved.

The spaces were both coordinated and differentiated by their decor—white, pink, and silver for the ladies' tea room; dark gray canvas paneling with touches of pink in the stenciled decorations for the rear dining room; lighter gray, white, and pink for the general tea gallery. The areas were also articulated by the use of two main chair designs, both dark-stained: a ladder-back with

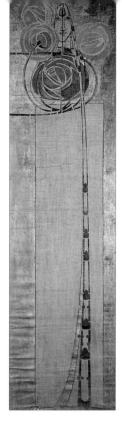

24. One of the stenciled linen panels that decorated the walls of the rear dining saloon at the Willow Tea Rooms, 1903. Hunterian Art Gallery, University of Glasgow, Mackintosh Collection, Glasgow

curved rungs (another of those visually strong chairs that are weak in construction) and a contrasting boxy armchair.

Up the stairs on the first floor, only customers willing to pay a bit extra would push open a pair of gorgeous doors to enter the enclosed space behind them, but many did it just to get a look. This was the Salon de Luxe, soon popularly known as the Room de Luxe, a kind of glittering treasure box of luxury, the ultimate example of the tea room as a work of art. Even the waitresses were particularly pretty. Some of this can be experienced today, though the present furnishing is not as Mackintosh ordained (please see "the Mackintosh Trail," page 98).

An old photograph shows eight high-backed silver chairs, decorated with oval cutouts and squares of purple glass, carefully lined up at the central tables on

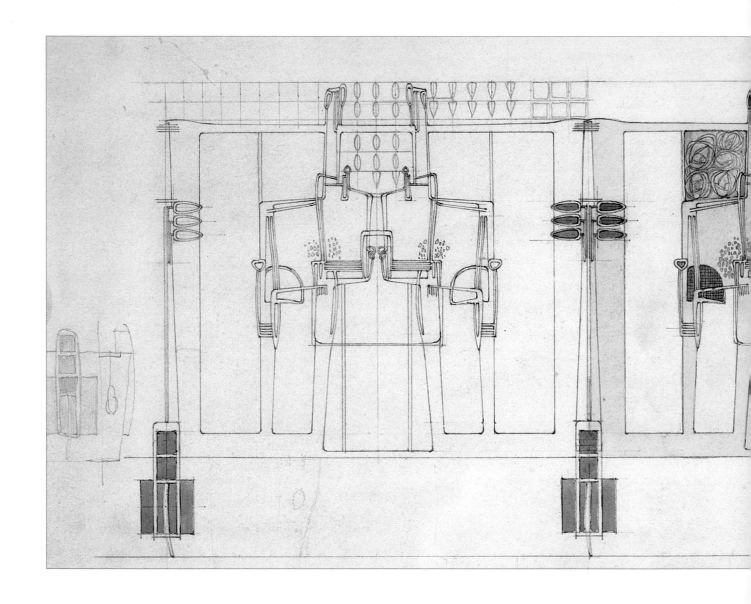

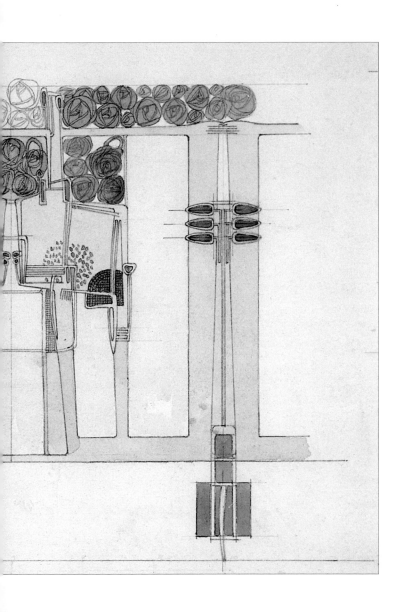

25. Mackintosh's design for the strange plaster frieze at the front of the Willow Tea Rooms, 1903. It can be seen above the entry passage in the photograph of the ladies' tea room on page 48. It was executed without the roses or the coloring shown in the drawing, as an austere abstract on the "willow" theme. Hunterian Art Gallery, University of Glasgow, Mackintosh Collection, Glasgow

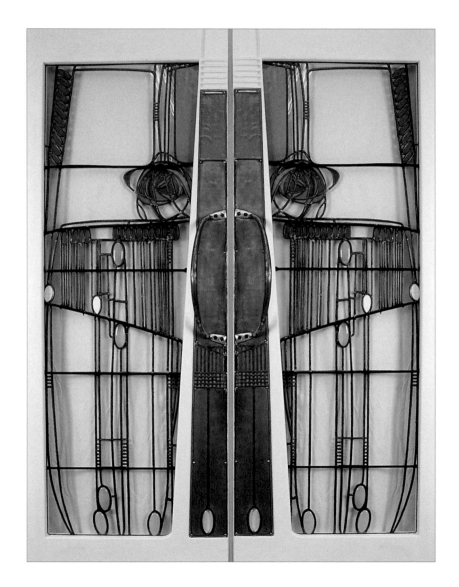

26. *The extravagant doors of the*
"Salon de Luxe" at the Willow Tea Rooms,
1903. Morgan Grenfell Property Asset
Management, Ltd.; photograph
by Marie Stumpf

27. *Opposite: A contemporary view of*
the "Salon de Luxe," laid for lunch.
Eight high-backed silver chairs stood at
the center tables. The formal arrangement
of the furniture is echoed in the carpet
design. Hunterian Art Gallery, University of
Glasgow, Mackintosh Collection

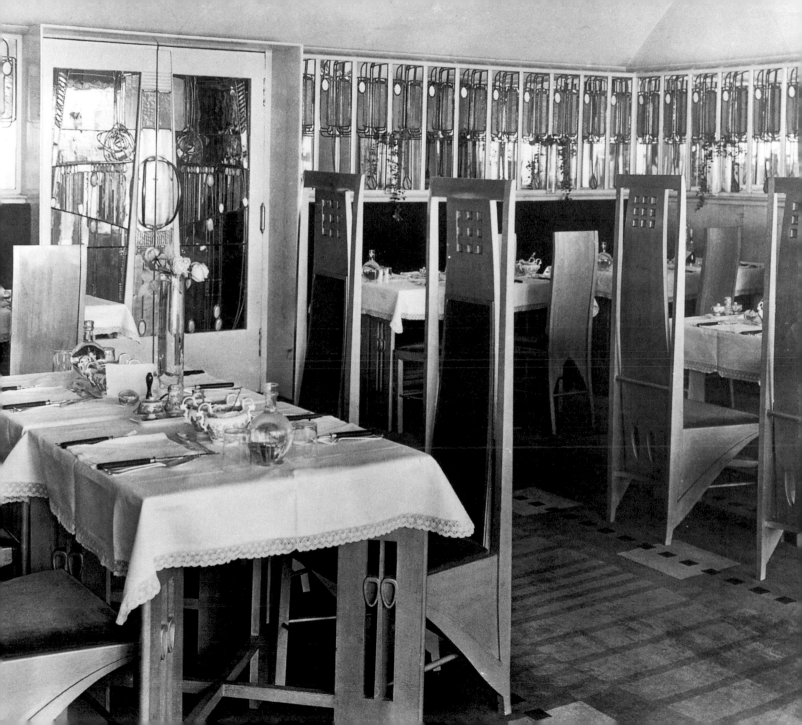

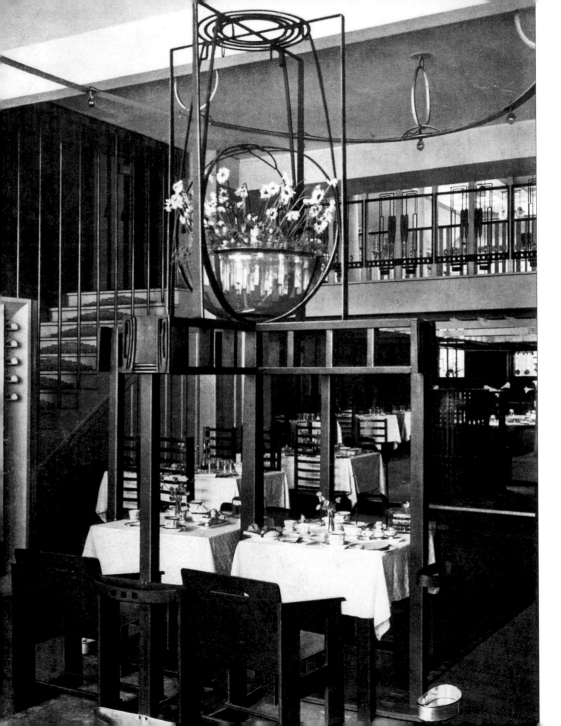

28. The center of the ground floor of the Willow, with the great flower bowl structure and the tall semicircular order-desk chair beyond marking the transition between the front tea room (behind the viewer) and the "solid food department." The open screened stairs led to the tea gallery and upper floors. Hunterian Art Gallery, University of Glasgow, Mackintosh Collection, Glasgow

the marked-out carpet. At the sides of the room are chairs with lower curved backs, also silver, and upholstered in purple velvet. The lower walls were paneled with silvery purple silk, stitched with beads down the seams. Margaret had contributed a decorative panel, in gesso, her favorite medium: three elongated ladies, dripping with strings of glass jewels, the title—*O Ye, All Ye That Walk in Willowwood* (page 61)—making at least a private connection with the willow theme that ran faintly through the interior designs. Above was a chandelier of countless pink glass baubles, remembered by a bewitched young Mary Newbery as "absolutely perfectly beautiful." Round the walls ran a frieze of leaded colored and mirror glass, reflecting and refracting the customers of this fantasy world.

This was all wildly overdone, but it was an experience, and it was very appealing—the people came, whatever they thought. Neil Munro caught

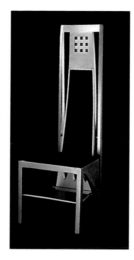

29. One of the extraordinary silver-painted chairs, with purple glass insets, which occupied the center of the "Salon de Luxe." Hunterian Art Gallery, University of Glasgow, Mackintosh Collection, Glasgow

this mixture of amusement and admiration in one of his popular "Erchie" columns in *The Evening News*. In "Erchie in an Art Tea-room" he exposes two working-class Glaswegians to "the refining and elevating influence of Miss Cranston's beautiful rooms," giving a nice contemporary perspective on the Willow.

Erchie tells how he met Duffy, a coal man in his Sunday best, flush with £3 10s insurance money for a dead horse, and deflected him from a pub to "thon new tearoom wi' the comic windows." When they reach it, Duffy is quite taken aback: 'Michty!' says he, 'wha did this?' 'Miss Cranston,' says I. 'Was she tryin'?' says Duffy. 'She took baith hands to't,' I tellt him. 'And a gey smert wumman too if ye ask me.' "

It takes some time to get Duffy inside, cap in hand. "He gave the wan look roond him, and put his hand in his pooch to feel his money"; but Erchie assures him it will cost no more than the

pub, and they start climbing the stairs. In each of the gaps between the rails is "a piece o' gless like the bottom o' a soda-water bottle, hangin' on a wire." Duffy thinks this is very fancy and touches them all for luck.

Even the suave Erchie is a little quelled by the interior: "I may tell ye I was a wee bit put aboot mysel' . . . There was naething in the hale place was the way I was accustomed to; the very snecks o' the doors were kind o' contrairy. 'This way for the threepenny cups and the guid bargains,' says I to Duffy, and I lands him into what they ca' the Room de Looks . . .

"There's . . . wee beads stitched a' ower the wa's the same as if somebody had done it themsel's. The chairs is no' like ony other chairs ever I clapped eyes on, but ye could easy guess they were chairs; and a' roond the place there's a lump o' lookin'-gless wi' purple leeks pented on it every noo and then."

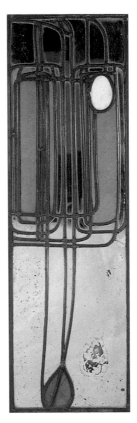

30. A leaded-glass panel from the frieze in the Salon de Luxe at the Willow Tea Rooms, shown in place in the photograph on page 57. Hunterian Art Gallery, University of Glasgow, Mackintosh Collection, Glasgow

Duffy can only speak in whispers. " 'My Jove!' says he, 'ye'll no' get smokin' here, I'll bate.' 'Smokin'!' says I; 'ye micht as weel talk o' gowfin'.' 'I never in a' my life saw the like o't afore. This cows a'!' says he, quite nervous and frichtened lookin'."

He revives slightly when one of the comely waitresses (dressed by Mackintosh in white with chokers of large pink beads) approaches for their order. " 'It'll likely be the Room de Good Looks,' says he . . . 'I'm for a pie and a bottle o' Broon Robin.' "

Erchie disabuses him of this: " 'Ye'll jist tak' tea, and stretch yer hand like a Christian for ony pastry ye want,' said I, and Duffy did it like a lamb. . . . It was a real divert. It was the first time ever he had a knife and fork to eat cookies wi', and he thocht his teaspoon was a' bashed oot o' its richt shape till I tellt him that was whit made it Art. 'Art,' says he, 'whit the mischief's Art.' "

Erchie then describes ruefully how Art broke
out in his own home when his wife was taken by
artistic tastes, and how it's now "ragin' a' ower
the place."

When Duffy persists in his wish for a pie, the
staple of a Glasgow high tea, Erchie takes him
down to the "solid meat department" (i.e., the
back saloon), on the grounds that "a pie's no
becomin' enough for the Room de Looks."

Here the novel system of ordering food from
the basement kitchen with color-coded balls
popped down a pipe is another source of won-
derment to Duffy—but as Erchie continues, "
'That's Art. Ye can hae yer pie frae the kitchen
withoot them yellin' doon a pipe for't and lettin'
a' the ither customers ken whit ye want.' When
the pie cam' up, it was jist the shape o' an ordi-
nary pie, wi' nae beads nor onything Art aboot
it, and Duffy cheered up at that, and said he
enjoyed his tea."

31. Decorative gesso panel by Margaret Macdonald, O Ye, All Ye That
Walk in Willowwood, *1903. It hung opposite the fireplace in the Salon
de Luxe at the Willow Tea Rooms. Private collection; photograph Glasgow
Museums and Art Galleries, Glasgow*

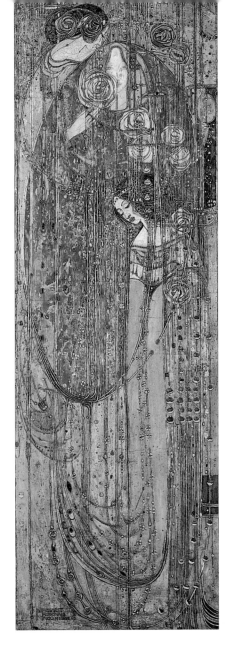

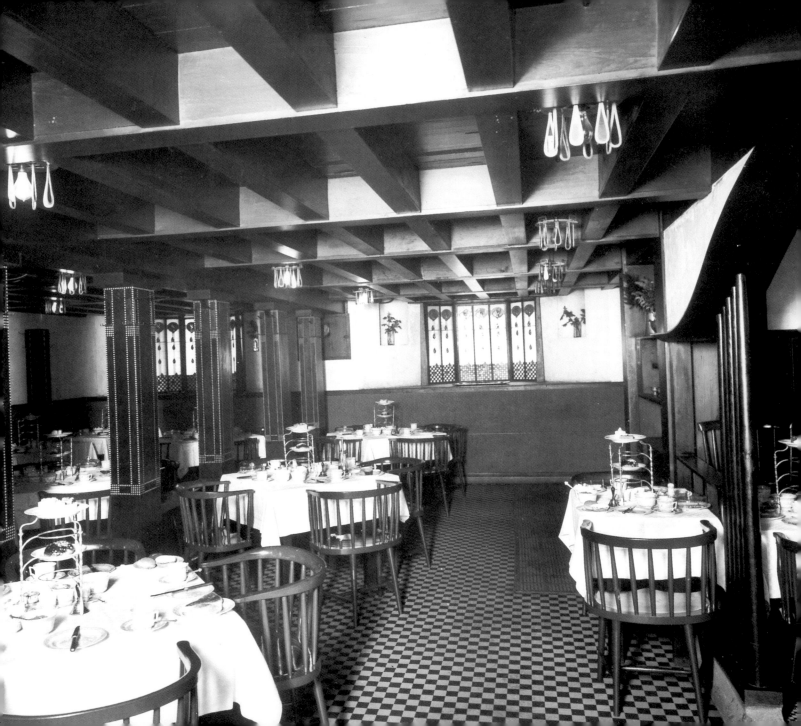

Help in Hard Times

Miss Cranston's warm relationship with Mackintosh must have been a significant commendation when Honeyman & Keppie, for whom he had been working since 1889, made him a partner in 1901. She came through not only with the big job at the Willow in 1903, but with a substantial private commission in 1904, when she asked Mackintosh to redecorate and furnish the Cochranes' grand new home, Hous'hill.

This was a fruitful job for Mackintosh, enabling him to pursue the creative move, already visible in his tea-room work, away from an organic, symbolic, and sensual style to the more austere fascinations of the square. And it shows too, better than anything, that Miss Cranston really meant it—that this 55-year-old middle-class lady entrepreneur did like Mackintosh's work enough to want to live with it.

His "domestic masterpiece," the Hill House at Helensburgh, and then the Scotland Street School, kept Mackintosh busy, and his star was bright on the continent too, in Germany and Austria. Margaret could write to Anna Muthesius at the end of 1904: "It is very amusing— and in spite of all the efforts to stamp out the Mackintosh influence—the whole town is getting covered with imitations of Mackintosh tea rooms, Mackintosh shops Mackintosh furniture &c—it is too funny—I wonder how it will end." (In the "Mockintosh" now plastered all over Glasgow, it seems.) But perhaps what she is talking about

32. The Dutch Kitchen, a new tea room designed by Mackintosh in the basement of the Argyle Street tea rooms, 1906. The inglenook is to the right. T. & R. Annan & Sons, Glasgow

here is the breakthrough, certainly spearheaded by Miss Cranston's tea rooms, of the Glasgow Style in general into middle-class taste. For, with one insignificant exception, none of Miss Cranston's competitors went so far as to commission designs from Mackintosh.

And quite unmistakably this was the end of the high tide for Mackintosh. Work began to dry up and he started to find himself out of sympathy with current architectural movements. Only Miss Cranston, impervious as ever to fashion, continued over the coming years as his staunch patron, deliberately finding jobs for him. Already in 1905, when Mackintosh had little else on hand, we find her playing the good fairy. She dreamed up the idea of making a new tea room in a basement of her Argyle Street establishment. Completed in 1906, this was a stunning expression of Mackintosh's new Vienna-influenced interest in small squares.

Kate may have given him the "Dutch Kitchen" concept. Perhaps she had collected some delft tiles—a popular "artistic" taste, close to her penchant for blue-and-white willow-pattern crockery. But a delft-tiled fireplace with rack for decorative plates above, and a fake inglenook were about as far as the Dutchness and kitchen-ness went. The Windsor-style chairs, traditional in form and sturdy for a change (so "normal" indeed that few have been identified) also alluded to the Olde Worlde country style now becoming established as a tea-room norm—except that Mackintosh made them emerald green. The rest was vibrant urban chic: a black ceiling, glittering mother-of-pearl squares up and down the columns, and a dazzling black-and-white checkerboard pattern on the floor (Mackintosh required the traditionally diamond-woven linoleum to be laid diagonally, so as to make squares, to the distraction of the workmen).

Back at her Ingram Street establishment, Miss Cranston took over No. 217, the last building on the corner, in 1907. Here Mackintosh produced a billiard room in the basement and, also

for men, the Oak Room—again per-
haps a nod to current "old oak" tea-
room style. In an awkward space he
made a galleried room very close in
style to the Glasgow School of Art
Library, commonly seen as his "mas-
terwork," which he was designing at
this time. The emphasis on the wooden
structure with odd undulating lathes
running over upright ribs, and cham-
fered detailing, was appropriate for a
rather dark masculine area.

In 1909 Kate managed to find another neglected
space at Ingram Street for Mackintosh to exercise his
ingenuity upon—he squeezed in the Oval Room and
a ladies' rest room—and she also had a card room
and other oddments done at home. But otherwise,
with the completion of the West Wing of the Glasgow
School of Art, Mackintosh had no work. Heavy
drinking became a problem, linked to depression.

Glasgow's big Scottish National Exhibition
of 1911 allowed Miss Cranston to bail the Mack-

*33. Light fixture for the
Oak Room, an extension
designed by Mackintosh at
the Ingram Street tea rooms,
1907. The undulating lattice
echoes the woodwork of the
gallery. Glasgow Museums
and Art Galleries, Glasgow*

intoshes out with a commission for her
temporary White Cockade tea rooms—
style on a tight budget was what was
required, but we do not know what it
looked like. Margaret got the job of
designing the menu card, which is rem-
iniscent of the smart Dutch Kitchen,
rather Viennese and stylish. It was sen-
sitive of Kate to ask Margaret's sister
Frances to do the card for her other
tea room at the exhibition, the Red
Lion. We do not know who designed its
interior—could it even have been Herbert
McNair, to complete the pattern of patronage to
the needy Four?

The Bailie marked Miss Cranston's promi-
nence at the exhibition with the accolade of its
"Men You Know" profile slot, accurately identi-
fying her gifts, including her shrewd understand-
ing of her market. "She has created a demand by
the supply of just the right thing, in just the right
way, at just the right price." She maintained her

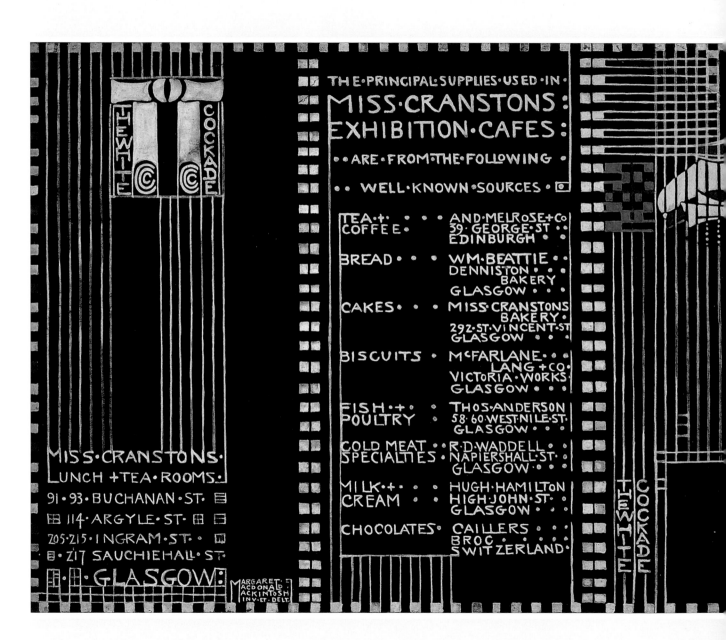

THE WHITE COCKADE

THE·PRINCIPAL·SUPPLIES·USED·IN·
MISS·CRANSTONS:
EXHIBITION·CAFES:
··ARE·FROM·THE·FOLLOWING·
··WELL·KNOWN·SOURCES·□

TEA·+· COFFEE·	AND·MELROSE+Cᵒ 39·GEORGE·ST· EDINBURGH·
BREAD···	WM·BEATTIE·· DENNISTON·· BAKERY GLASGOW···
CAKES···	MISS·CRANSTONS· BAKERY· 292·ST·VINCENT·ST GLASGOW···
BISCUITS·	McFARLANE·· LANG+Cᵒ· VICTORIA·WORKS· GLASGOW···
FISH·+· POULTRY	THOS·ANDERSON 58·60·WEST·NILE·ST· GLASGOW···
COLD·MEAT· SPECIALTIES·	R·D·WADDELL·· NAPIERSHALL·ST· GLASGOW···
MILK·+· CREAM	HUGH·HAMILTON HIGH·JOHN·ST· GLASGOW···
CHOCOLATES·	CAILLERS··· BROC· SWITZERLAND·

MISS·CRANSTONS·
LUNCH+TEA·ROOMS·
91·93·BUCHANAN·ST·
114·ARGYLE·ST·
205·215·INGRAM·ST·
217·SAUCHIEHALL·ST
GLASGOW:

MARGARET·
MACDONALD·
MACKINTOSH·
INV·ET·DELT·

THE WHITE COCKADE

34. The smart menu card designed by
Margaret Macdonald for Miss Cranston's
White Cockade tea rooms at the Scottish
National Exhibition of 1911. Hunterian Art
Gallery, University of Glasgow, Mackintosh
Collection, Glasgow

:: Tea-Room Tariff ::

Tea—

CUP OF TEA,	Small,	3d.
CUP OF TEA,	Large,	4d.
RUSSIAN TEA,	Glass,	3d.
POTS OF TEA (2 or 4 Cups),	Per Cup,	3d.

Melrose's "Queen's Tea" used, 3/2 per lb.

Coffee, Cocoa, Chocolate—

CUP OF COFFEE OR COCOA,	Small,	3d.
CUP OF COFFEE OR COCOA,	Large,	4d.
CUP OF CHOCOLATE AND WHIPPED CREAM,		4d. and 6d.

Melrose's Coffee used, 2/- per lb.

Milk—

GLASS OF MILK,		2d.
GLASS OF MILK, HOT,		3d.
GLASS OF BUTTER MILK,		1½d.

Breads—

BREAD, BUTTERED,	Per Slice,	2d.
SCONES, BUTTERED,	Each,	2d.
PANCAKES, BUTTERED OR JELLIED,	"	2d.
PANCAKES OR SCONES, HOT, JELLIED	"	2d.

(Served for Afternoon Tea.)

POTATO SCONES, BUTTERED,		1d.
BREAD, SCONES, AND PANCAKES, Plain,		1d.
POT OF JAM, JELLY, OR MARMALADE,		1d.

Cakes—

CAKES, All Varieties,	Each,	2d.
BISCUITS, MIXED, in Special Packets,	"	2d.
BISCUITS, Varied, Plain,	"	1d.
BUNS, Varied, Plain,	"	1d.
POT OF JAM, JELLY, OR MARMALADE,		1d.

Sandwiches and Pies and Snacks—

SANDWICHES, Varied,	Each,	3d.
MUTTON PIES, HOT,	"	3d.
SNACK PIES, HOT,	"	4d.
SAUSAGE AND CHIPS,		4d.
SAVOURY MEAT RISSOLE, TOMATO SAUCE, AND CHIPS,		4d.
MINCE, CURRIED OR PLAIN,	Small,	6d.

Luncheons and High Teas

A la Carte or at Fixed Price. (See End.)

Soups—

CUP OF KIDNEY AND OTHER SOUPS AND CRUST,		3d.
BASIN OF KIDNEY AND OTHER SOUPS AND BREAD,		4d.
CUP OF CREAM SOUP AND CRUST,		4d.
BASIN OF CREAM SOUP AND BREAD,		6d.

Fish Dishes—

FISH RISSOLE AND CHIPS,		4d.
POTTED HERRING, SALAD, AND POTATO,		4d.
FRIED WHITING OR HADDOCK,		9d.
FILLETED SOLE AND CHIPS,	Small,	6d.
FRIED FILLETED SOLE AND PARSLEY SAUCE,		1/-

LUNCHEONS AND HIGH TEAS—Continued.

Egg Dishes—

POACHED EGG ON BUTTERED TOAST,	4d.
POACHED EGGS (2) ON BUTTERED TOAST,	6d.
SCRAMBLED EGGS ON BUTTERED TOAST,	6d.
SCRAMBLED EGG, FISH, AND RICE,	6d.
BACON AND EGG,	6d.
BACON AND EGGS (2),	10d.
SAUSAGE AND EGG,	6d.
SAUSAGES AND EGGS,	10d.

Cheese Dishes—

WELSH RAREBIT,	4d.
WELSH RAREBIT AND POACHED EGG,	6d.

Hot Meats, Pies, and Savouries—

MUTTON PIES,	Each,	3d.
SAVOURY MEAT RISSOLE AND CHIPS,	"	4d.
CHICKEN PATTIE,	"	8d.
MINCE, PLAIN OR CURRIED, AND POTATO,		8d.
ROAST BEEF, VEGETABLE, & POTATO,	Small,	8d.
Do., do., do.,	Large,	1/-
ROAST LAMB, GREEN PEAS, & POTATO,	Small,	8d.
Do., do., do.,	Large,	1/2
CHICKEN FRICASSEE AND HAM,		10d.
LAMB CUTLETS, PEAS, AND TOMATO SAUCE,		1/3
MIXED GRILL AND POTATOES,		1/-
GRILLED STEAK AND POTATOES,		1/3

Cold Viands—

SANDWICHES, Varied,		3d.
POTTED MEAT, SALAD, AND POTATO,		6d.
VEAL, HAM AND EGG PIE, POTATO, AND SALAD,		6d.
Do., do., do.,	Large,	1/-
ROAST BEEF, do.,	Small,	8d.
Do., do.,	Large,	1/-
ROAST LAMB, do.,	Small,	8d.
Do., do.,	Large,	1/-
BRAISED BEEF, do.,		8d. and 1/-
ROAST CHICKEN AND HAM, POTATO, AND SALAD,		1/3

Sweets, Hot—All Served with Cream—

FRUIT TARTS,	6d.
STEAMED FRUIT PUDDING AND CUSTARD SAUCE,	6d.
CUSTARD PUDDING,	6d.
RICE CUSTARD PUDDING, WITH OR WITHOUT STEWED FRUIT,	6d.
PEACH TARTLET AND WHIPPED CREAM,	6d.

Sweets, Cold—All Served with Cream—

CALF FOOT JELLY,	6d.
CURDS AND CREAM,	6d.
DEVONSHIRE JUNKET,	6d.
CHARLOTTE RUSSE,	6d.
STEWED PRUNES, FIGS,	6d.
COMPOTE OF FRUITS,	6d.
SWISS TART,	6d.
PEACHES AND CLOTTED CREAM,	6d.
STEWED FRESH FRUITS IN SEASON AND CLOTTED CREAM,	6d.
TARTS, FRUITS IN SEASON,	6d.
STRAWBERRIES AND CREAM,	6d.

Carson & Nicol, Ltd., Printers, Glasgow.

Special Fixed Price Luncheons

Served 12-3 Daily in Saloons.

2/6 FIVE COURSE, CONSISTING OF SOUP, FISH, ENTREE, JOINT, AND SWEET.

2/- FOUR COURSE, CONSISTING OF SOUP, FISH, ENTREE OR JOINT, AND SWEET.

(See separate Menu on Table.)

Fixed Price High Teas

Served in Saloons at all Hours.

9d. each. CUP OF TEA, WITH POACHED EGG ON TOAST, or WELSH RAREBIT, or MUTTON PIE, or COLD BAKED HERRING AND SALAD. SLICE BUTTERED BREAD AND A CAKE or BUTTERED SCONE FROM STAND.

1/- each. CUP OF TEA (LARGE), WITH HAM AND EGG, or SAUSAGE AND EGG, or FILLETED SOLE AND CHIPS, SLICE BUTTERED BREAD AND A BUTTERED SCONE OR CAKE FROM STAND.

1/6 each. POT OF TEA, WITH BACON AND TWO EGGS, or FILLETED FISH (LARGE) AND CHIPS, AND ANY THREE ARTICLES FROM BREAD STAND.

Fixed Price Plain Teas

Served in Saloons at all Hours.

6d. CUP OF TEA, WITH SLICE BUTTERED BREAD AND CAKE.

9d. CUP OF TEA (LARGE), WITH SLICE BUTTERED BREAD, BUTTERED SCONE AND CAKE.

1/- POT OF TEA, WITH SLICE BUTTERED BREAD, BUTTERED SCONE, AND TWO CAKES, WITH POT JAM.

Ices—

VANILLA ICE CREAM,	6d.
VANILLA ICES, WITH FRUIT SYRUP,	6d.
VANILLA ICES, WITH SLICE PEACH,	6d.
ICED MERINGUES,	6d.

Drinks—

SODA, LEMONADE, STONE GINGER,	3d.
GINGER ALE,	3d.
LEMON SQUASH,	4d.
LIME JUICE SQUASH,	4d.
SPARKLING KOLA,	4d.
MILK AND SODA,	4d.
CREAM AND SODA,	4d.

success, which enabled her continuing patronage of Mackintosh, by attention to detail on every front, touring her establishments daily to keep everything up to the mark.

Continuing her practical efforts to pull Mackintosh out of the doldrums, Miss Cranston requested the wholesale redesigning of two rooms at Ingram Street later in 1911, and Mackintosh grasped with both hands these rare opportunities for creative work. The Chinese Room for male use had a black ceiling and was divided up and paneled with lattice screens painted powerful lacquer blue, with touches of red, and little concave niches of mirror-glass glitter and a new colored plastic—all very strong, dark, exotic, and again quite undomestic. Strong color was also used to pick out little strings of decoration on warm waxed wood in the Cloister Room, a barrel-vaulted enclosing womb, full of ripple and undulation, glamorized with niches of mirror glass. These interiors seem new and strange and show a famished designer eager to develop new ideas.

35. Section of paneling from the Chinese Room at Ingram Street, 1911. Mackintosh was experimenting with strong color, filling squares and niches with mirror glass and a recently invented plastic material. Glasgow Museums and Art Galleries, Glasgow

36. Opposite:The menu for Miss Cranston's tea rooms at the 1911 Scottish National Exhibition held in Glasgow in 1911. Hunterian Art Gallery, University of Glasgow, Mackintosh Collection, Glasgow

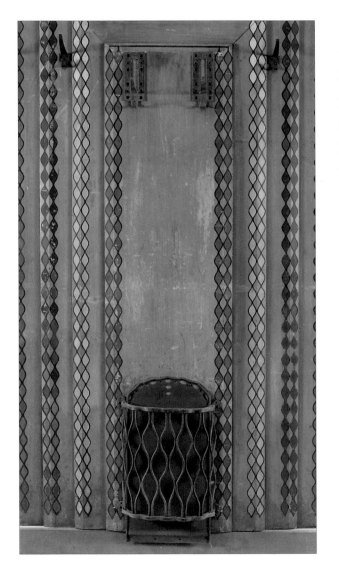

But things were now quite bad for Mackintosh, who was generally depressed, isolated, and unable to hold things together. For some time he had not been pulling his weight in the partnership and tensions erupted in the middle of 1913. After his resignation he made a hopeless attempt to go into business by himself—but even Miss Cranston could not think of anything more for him to do. The Mackintoshes left Glasgow in 1914 just before the outbreak of the First World War for a long holiday at Walberswick in Suffolk from which they never returned. Flower painting and rest seem to have restored Mackintosh's spirits. He and Margaret moved to London, to Chelsea, where they scraped along not unhappily among stimulating bohemian friends.

In 1916 Miss Cranston sent a job from Glasgow, especially welcome in these thin wartime years: she

37. Section of wall paneling with an umbrella stand from the Cloister Room at Ingram Street, 1911. Glasgow Museums and Art Galleries, Glasgow

38. Opposite: Design by Mackintosh for the Dug-Out, an underground extension at the Willow Tea Rooms, opened in 1917. Glasgow School of Art, Glasgow

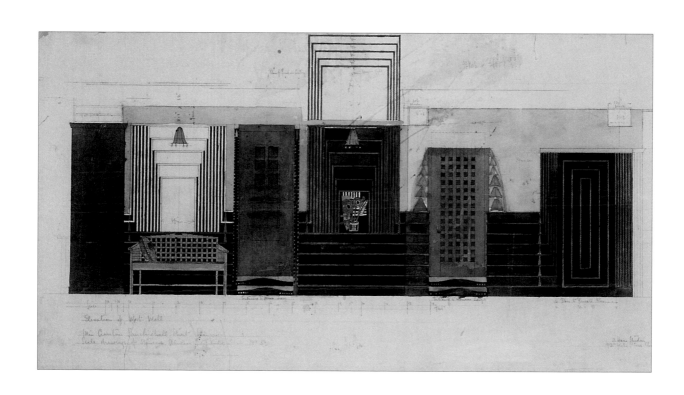

had managed to gouge out an underground extension to her Willow Tea Rooms. This coincided with a commission to restyle a small house in Northampton for a new patron, W. J. Bassett Lowke. The two jobs gave Mackintosh a rare chance to develop his new interest in a geometric style and jazzy

39. Settee designed for the Dug-Out at the Willow Tea Rooms, opened in 1917. Glasgow School of Art, Glasgow

color: to the squares and latticework he had already explored were now added stripes and jagged triangles, in strong colors against a black background. Miss Cranston also took a couple of paintings, *The Little Hills*, executed by Margaret and featuring rather repellent-looking toddlers, to be incorporated as a frieze. It is hard to imagine the effect of this artificially lit subterranean tea room: it has vanished without trace.

A plaque over the fireplace memorialized the opening of the Dug-Out in the late summer of 1917 "during the Great European War." It was Miss Cranston's last venture. In October her husband, John Cochrane, died. He was the prop of his wife's flamboyant persona; they had been devoted to each other. She was shattered, and it was the end of her business. She disposed of the tea rooms and her lovely house with its Mackintosh furnishings and moved into the North British Hotel, overlooking the site of her birth in George Square. She was still to be seen, though, on the streets of Glasgow, dressed always in black in a style of "extreme picturesqueness."

It was more or less the end of Mackintosh's architectural career too. Few of the designs he worked on in London came to fruition. In 1923 he and Margaret drifted away to obscurity in the South of France. They had each other, they lived inexpensively, and Mackintosh painted.

Miss Cranston and Mackintosh

Mackintosh died of cancer of the tongue on December 10, 1928, leaving watercolors, furniture, and belongings valued at £88 12s 6d. Margaret wandered about for a few years until her death in 1933. Miss Cranston outlived them both, though in these last years she became distressingly vague and alarming. She died on April 18, 1934, leaving a fortune of £64,476.

Mackintosh gave Miss Cranston some remarkable interiors, a distinctive "house style" that contributed greatly to her fame and fortune. He gave her the opportunity to exercise and enhance her individualism through her patronage, which she evidently enjoyed: she was someone who liked to be doing.

What Miss Cranston gave to Mackintosh is also clear. If a talent such as his is to be developed to the full, somebody has to pay for it. The constant stream of jobs from Kate Cranston was Mackintosh's bread and butter, to use an appropriate image, and particularly important in the later difficult years. But the work was not just bread and butter: what could be more like icing on the cake than the Salon de Luxe at the Willow? In the tea rooms Mackintosh was able to realize with remarkable freedom the ideas that were preoccupying him. Thus they represent the full range of his stylistic development—"feminine" and "masculine"; symbolic, curvilinear sensuality and geometric chic; interiors in white, pink, gray, and silver and in black, blue, red, and yellow.

Miss Cranston's apparent lack of interference might seem surprising, for she was a strong-willed woman, more than a shade imperious, with very definite ideas about the running of her business.

But she had good instincts. A perfectionist herself, she responded positively to that quality in Mackintosh that eventually contributed to making him unemployable: although he had a likable, generous nature, there was iron in him when it came to the way he wanted things.

Her accepting attitude gave him respite from the irksome restraints of building committees on more institutional jobs. He apparently felt his dealings over the Glasgow School of Art, for instance, had been "a daily fight" for three years. This trust and moral support over twenty years was surely precious to someone who often felt himself the victim of criticism. In March 1903, for example, he wrote to Anna Muthesius that "antagonisms and undeserved ridicule, bring on feelings of despondency and despair"; but he could say in the same letter, about his current work on the Willow, "Miss Cranston is delighted with everything I have suggested, she thinks this is going to be by far her first place." She stuck with him through thick and thin, and her strong, cheerful character must often have borne him up.

A tea-room commission was perfectly suited to Mackintosh's ideal of a complete controlled interior, with every detail meticulously thought out. Furniture exactly placed was crucial to this effect: under Miss Cranston's keen eye it would not be casually shuffled about and everything would be kept just so. In domestic interiors, it was only in the Mackintoshes' own house that living clutter and disharmony could be excluded in deference to the aesthetic effect—something that strikes everyone who visits the Mackintosh House at the Hunterian Art Gallery today. But in the tea rooms, the decorative overstatement, novelty, and even discomfort that might have been too much in a domestic interior lent appropriate excitement to the business of eating out.

That Miss Cranston's commitment was vindicated is gratifying. People evidently loved

the experience of these weird and wonderful interiors. They lived at home, as we do mostly, with safe choices and a variety of accumulated objects, constrained by practicalities: the room as a work of art is not the room most people would want to live in. But the appeal of the complete artistic interior, with nothing extraneous about it, is clear all the same. Miss Cranston's tea rooms offered a streamlined, artistically charged world separated from the humdrum disorder of life outside, though not without a comfortingly domestic substructure. To go and play in this specialness for the price of tea and a cake was very attractive. And this in turn made Mackintosh's work an accessible part of the lives of countless ordinary people, far more than he could have touched as the designer only of private houses and a few institutional buildings.

The bottom line, of course, is that whatever artistic fulfillment Mackintosh derived from being able to work in these conditions, it was Miss Cranston's name, not his, that was attached to the achievement. "Everybody knows Miss Cranston. Her name is a household word in Glasgow and the West of Scotland; her renown has spread far and wide," wrote *The Bailie* in 1911. In line with the pattern of many a "genius" story, it has been left to posterity to reward Mackintosh with adulation and fame far beyond his native city. And it is now Miss Cranston who is saved from obscurity by her protégé.

So this is a story of what two gifted people, patron and artist, did for each other, and for the world at large. Belated efforts to salvage bits and pieces of this achievement continue; but we should perhaps simply feel grateful to them both for this glimpsed experience of interiors where, as Neil Munro wrote, "everything was 'different' and the whole atmosphere was one of gay adventure."

NOTE·TO·VISITORS

MISS·CRANSTON
PROVIDES·AT·ALL
HER·PLACES·
SMOKING····AND
REST·ROOMS
FOR·THE·VSE·OF·HER
PATRONS·WHO·ARE·
ASKED·TO·TAKE·FVLL
ADVANTAGE·OF·THE·
FACILITIES·THEY·OFFER
FOR·MEETING·BUSINESS
FRIENDS·OR·RESTING
BETWEEN·BUSINESS·
···ENGAGEMENTS···

TELEPHONES·WRITING
DESKS·LATEST·NEWS
TELEGRAMS·NEWSPAPERS
DAILY·AND·WEEKLY·
BILLIARD'S·CHESS·
▓·DRAVGHTS·▓

AT·INGRAM·STREET·ADDRESS
▓·A·SPECIAL·REST·ROOM·FOR·▓
BVSINESS·LADIES·IS·PROVIDED

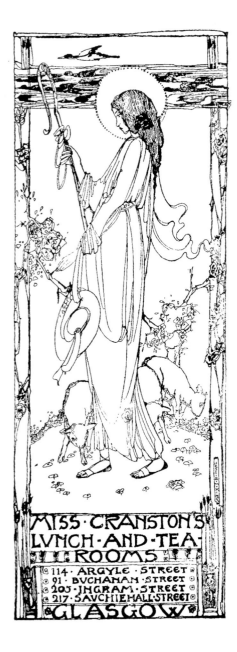

MISS·CRANSTON'S
LVNCH·AND·TEA
▓▓▓·ROOMS·▓▓▓
⊙ 114·ARGYLE·STREET ⊙
⊙ 91·BVCHANAN·STREET ⊙
⊙ 205·INGRAM·STREET ⊙
⊙ 217·SAVCHIEHALL·STREET ⊙
GLASGOW

40a. and 40b. Menu for
Miss Cranston
designed
by Jessie King,
a leading Glasgow
Style artist, between
1911 and 1917.
Glasgow Museums and
Art Galleries, Glasgow

TRADITIONAL TEA-ROOM RECIPES

Traditional Tea-room Recipes

Taking tea with the Mackintoshes themselves was an "exquisite rather than lavish" affair, as remembered by Mary Newbery Sturrock, the daughter of Fra and Jessie Newbery. But it was a happy occasion too: Mackintosh, from a large family but childless, loved young people. Mary Sturrock recalls chairs around a glowing red fire, the house so "pretty and fresh," and the pair of them so "awfully nice"—a cheerful friendly atmosphere, a lot of fun.

Every detail of a Mackintosh interior was carefully harmonized—down to their gray Persian cats on gray corduroy cushions. It is not surprising then that even the cakes we hear of—meringues and the Mackintoshes' favorite "sand cake"—were pale and elegant, in keeping with the overall aesthetic effect. The same fastidiousness governed their choice of tea. Margaret, at least, apparently preferred the delicacy of China tea: in a late letter, Mackintosh

refers to having received her special blend, a green flowery Pekoe, which he has put carefully in its tin.

The sand cake (see page 97) was bought from a baker and so, doubtless, were the meringues. This was normal practice: baking at home was not easy in the days before reliable thermostatically controlled ovens, and Glasgow had many particularly fine bakeries. Many of them opened tea rooms at their shops, and these bakery tea rooms, some of them with several branches, came to dominate the tea-room scene after the First World War.

Scots have a notorious sweet tooth, and tons of breads, biscuits, and cakes were consumed daily, both at home and in tea rooms, at afternoon tea and at that mainstay of ordinary Scottish eating, "high tea." This meal, for those unfamiliar with it—and it always amazed visitors from other lands—was like an afternoon tea and evening meal rolled into one. It offered a main dish like fried fish and chips, smoked haddock and poached eggs,

mutton pie, or perhaps ham and egg, together with various breads and a selection of cakes, all washed down with a pot of tea. It could be served until the tea rooms' closing time at around 7 o'clock.

Afternoon tea was a daintier affair. The table in a tea room usually stood ready with plates of sliced breads, often under glass domes to keep them fresh, and presided over by the three-tiered cake stand. It was generally understood that you had to work from the bottom of the cake stand up, filling up a bit with plainer fare—scones, pancakes, and the like—before you were allowed to choose one of the fancy cakes from the top. Even then such treats were not routine. Miss Cranston's young relation John Mackinlay remembered his longing for the iced French cakes at the top of the stand, which were not allowed on normal days.

Miss Cranston's menus do mention French cakes, but otherwise tend to list "cakes, various," and we cannot say exactly what came out of her

kitchens or from the St. Vincent Street bakery, which supplied her four tea rooms after 1909. Her food always had a good reputation, however. The following selection of recipes concentrates on components of a traditional Glasgow tea that are easy to make at home. Some favorites of the cake stand, like the desirable French cakes, which according to professional bakers involve 14 different procedures, have been left out for obvious reasons. The cakes are on the whole drier in style than today's, but I have smuggled in cream cakes, which really only became popular after the First World War. You will notice also the absence of chocolate.

Note:

I have given liquid measurements in fluid ounces to avoid transatlantic confusion: a British pint is 20 fluid ounces, an American pint is 16 fluid ounces (or 2 cups). Follow only one set of measurements: do not mix metric and imperial quantities. Also remember that the oven should always be well heated before you put anything into it to bake.

Currant Bread

Currant bread was one of the first parts of a tea, and tea rooms each had their own esteemed recipes. For home consumption, it would have been bought at a bakery, but it is simple enough to make—and very good. When it is past its best, it's delicious toasted.

450 g (1 lb/4 cups) strong white (bread) flour
1 teaspoon salt
50 g (2 oz/1/4 cup) caster (superfine) sugar
1 package (4 teaspoons) easy blend (active dry) yeast
60 g (2 oz) butter
225 ml (8 fluid oz/1 cup) milk
1 egg, beaten
225 g (8 oz/1 1/2 cups) currants or sultana raisins
25 g (1 oz/3 tablespoons) mixed peel (mixed candied fruit)

Grease a 23 cm x 12 cm x 7.5 cm (9 inch x 5 inch x 3 inch) loaf pan. Mix the flour, salt, and sugar; warm gently in a low oven. Add the yeast. Combine the butter and milk in a small saucepan and place over low heat until the butter is melted. Remove from heat; when it is just warm to the touch, add the liquid to the flour with the egg. Mix well. Stir in the fruit (if you like you can plump up the fruit by moistening it beforehand with a little warm water, tea, or even something alcoholic).

Knead the dough for about 5 minutes. Put back in the bowl and cover loosely with a damp cloth or a plastic bag; let stand in a warm place (an oven turned on low for a few minutes, then turned off again, works well) until it has more or less doubled in size. Knead again, shape it to fit the greased pan, and place it in the pan. Cover again with plastic and let stand in the warm place until it doubles again. Heat the oven to 190° C (375°F). Bake the bread about 20 minutes, watching to avoid burning the top. Remove the loaf from the pan and put it back into the oven for 5 minutes. It is fully baked when it sounds hollow when tapped on the base. For a sweet top, brush with some runny honey or a sugar-and-water syrup.

Makes 1 loaf.

Scones

There are countless varieties of scones in traditional Scottish bakery. These are simple, plain scones, to which raisins may be added if you wish. Warm from the oven, spread with butter and good jam, they are a perennially popular part of a proper tea. The secrets of baking them at home are lightness of touch and speed, keeping them thick, and a good hot oven. For richer scones, add one beaten egg, then just enough milk to make a soft dough.

> 250 g (8 oz./2 cups) self-raising (self-rising) flour
> pinch salt
> 2 teaspoons baking powder
> 50 g (2 oz.) butter
> 30 g (2 tablespoons) caster (superfine) sugar
> handful of sultana raisins (optional)
> 120 ml (4 fl oz/1/2 cup) milk, or a little more if necessary

Preheat oven to 220°C (425°F) and grease a baking sheet. Sift together the flour, salt, and baking powder; with fingers, work in the butter until the mixture resembles bread-crumbs, or mix in a food processor. Add the sugar, and the sultanas if you want them. Mix in enough milk to make a soft dough. Roll it out lightly on a floured surface—it should be good and thick, about 2 cm (3/4 inch). Cut out rounds with a pastry cutter or cut into triangles; place on prepared sheet. Brush tops with milk or dust with flour. Bake 8 to 10 minutes.

Makes about 12 scones.

Scotch Pancakes

These are small, thick pancakes, cooked on a griddle. They were popular because they could easily be made at home over the fire of the kitchen range. They are good with butter and jam.

125 g (4 oz/1 cup) self raising (self-rising) flour
pinch salt
30 g (2 tablespoons) caster (superfine) sugar
150 ml (5 fl oz) milk
1 egg

Blend all the ingredients in a food processor or with an electric mixer for one minute. Allow the batter to stand briefly. Grease a griddle or heavy frying pan and heat it until drops of water dance on the surface. Drop spoonfuls of the batter onto the griddle. When bubbles have formed on the surfaces and the undersides are nicely brown, flip the pancakes over and cook briefly until done.

Makes about 14 pancakes.

Oatcakes

Oatcakes are part of the traditional repertoire of Scottish baking because, again, they can be cooked without an oven: very healthy, very easy, and very good eaten fresh from the griddle.

> 120 g (4 oz/2/3 cup) medium or fine oatmeal
> 1/4 teaspoon bicarbonate of soda (baking soda)
> 1/4 teaspoon salt
> 10 g (1/2 oz/1 tablespoon) melted butter, lard, or bacon fat

Combine the oatmeal, soda, and salt. Combine the butter with a little hot water in a small saucepan over low heat until butter is melted. Stir into the dry ingredients to make a dough. Dust a smooth surface with fine oatmeal and roll out the dough into a thin round. Cut it into quarters. Heat a griddle or heavy frying pan (not greased) until drops of water dance on the surface, and cook the oatcakes until the edges curl; they should not brown. Turn and finish cooking. Alternatively, the oatcakes can be baked in a preheated 190°C (375°F) oven for 15 to 20 minutes.

Makes 4 oatcakes.

Shortbread

This is a Scottish speciality, easy to make and always good with fruit and creamy desserts as well as by itself. Enrichments like candied fruit or chopped almonds can be added if wished. Semolina is less easy to find in the U.S. than in the U.K. Try health-food stores or Italian markets if your supermarket does not have it.

> 200 g (8 oz/2 cups) plain (all-purpose) flour
> 50 g (2 oz/1/2 cup) semolina
> 150 g (8 oz) butter, at room temperature
> 75 g (4 oz/2/3 cup) sugar

Preheat oven to 170°C (325°F). Mix all the ingredients in a food processor or with an electric mixer until they begin to bind into a dough. Knead together into a ball and roll out on a floured surface into a round. Transfer into a shallow 23 cm (9 inch) diameter pan, pinch around the edges to give a decorative finish, and prick all over with a fork. Bake for approximately 30 minutes; the shortbread should not brown too much. Mark it into wedges while still warm from the oven, then allow it to cool before serving.

Makes 8 wedges.

Abernethy Biscuits

These crisp biscuits are traditionally flavored with caraway seeds, but if you don't like the taste, the seeds can be omitted.

> 200 g (8 oz/2 cups) plain (all-purpose) flour
> $1/2$ teaspoon baking powder
> pinch salt
> 75 g (3 oz) butter or margarine
> 50 g (2 oz/$1/3$ cup) sugar
> 2 teaspoons caraway seeds
> 2 tablespoons milk, approximately

Preheat oven to 190°C (375°F). Lightly grease a baking sheet, or line it with baking parchment. Sift together the flour, baking powder, and salt. With your fingers, work the butter into the flour, or mix in a food processor. Stir in the sugar and caraway seeds. Mix in enough milk to make a pliable dough. Roll out thinly on a floured surface and cut into 6 cm (2$1/2$ inch) rounds. Prick the rounds all over and place on the prepared baking sheet. Bake until pale brown and crisp, about 12 minutes.

Makes about 40 biscuits.

Perkins

Also called parkins, these are plump gingery biscuits (cookies) with a bite of oatmeal in them.

> 200 g (8 oz/2 cups) plain (all-purpose) flour
> 200 g (8 oz/1 1/3) cups) oatmeal
> 150 g (6 oz/scant cup) sugar
> 1/2 teaspoon baking soda (bicarbonate of soda)
> 2 1/2 teaspoons ginger
> 1/2 teaspoon nutmeg
> 1/2 teaspoon allspice
> 1/2 teaspoon cinnamon
> 100 g (4 oz) butter or margarine
> 1 egg, beaten
> 6 tablespoons golden syrup (light corn syrup)
> almonds, whole or halved

Preheat oven to 180°C (350°F) and grease a baking sheet. Combine the dry ingredients. With your fingers, work in the butter until it resembles breadcrumbs, or mix in a food processor. Add the beaten egg and syrup and mix to form a dough. Roll the dough into balls the size of golf balls. Put an almond on each and flatten slightly. Bake about 15 minutes on prepared baking sheet.

Makes about 30 cookies.

Empire Biscuits

These sandwich cookies are good to make with children: the recipe is simple, and children love the icing. Empire biscuits were called German biscuits until the First World War, when they were renamed. Other decorations may be substituted for the glacé cherries.

> 100 g (4 oz) butter
> 150 g (6 oz/1 $^{1}/_{2}$ cups) plain (all-purpose) flour
> 50 g (2 oz/$^{1}/_{3}$ cup) caster (superfine) sugar
> 2 tablespoons milk, approximately
> 2 tablespoons jam, approximately
> 100 g (4 oz/$^{2}/_{3}$ cup) icing sugar (confectioners' sugar)
> glacé cherries

With your fingers, work the butter into the flour until it resembles breadcrumbs; then add the caster sugar (or mix all together in a food processor). Add enough milk to make a good pliable dough. Place it in the refrigerator, covered, until it is firm. Pre-heat oven to 170°C (325°F) and grease a baking sheet. Roll out the dough-like pastry about $^{1}/_{2}$ cm ($^{1}/_{4}$ inch) thick. Cut out 16 rounds about 6 cm (3 inches) in diameter and place on the prepared baking sheet. Check the rounds after 10 minutes —they should not be too brown, just pale and looking fully baked. Cool on a rack.

Join 2 rounds together with jam to make each "sandwich." Sift the icing sugar into a bowl and add hot water, a very little at a time, to make icing that is thick enough to spread smoothly over the cookies and stay there. Decorate each sandwich with half a cherry.

Makes 8 "sandwiches."

Meringues

So renowned were Miss Cranston's tea rooms that they automatically became the setting for this corny old joke:

> Him: Well noo, Jeanie, ye'll hae a cookie or a meringue?
> Her: Naw Jock, you're right, I'll hae a cookie. *

Chaste white meringues appeared too on Mackintosh's tea table. His niece remembers going to a Christmas party there after Uncle "Tosh" and Aunt Margaret got married, and having her first meringue and not knowing how to eat it.

> 3 egg whites
> 175 g (6 oz/scant cup) caster (superfine) sugar
> 175 g (6 fl oz) whipped cream, approximately

Preheat oven to 100°C (200°F). Line a baking sheet with baking parchment and coat the paper with vegetable oil. Beat the egg whites until the mixture makes soft peaks and does not slide out of the bowl (do not overbeat). Slowly add the sugar, beating after each addition. Spoon the mixture (or use a piping (pastry) bag with a wide nozzle if you want to be more professional) into conical heaps on prepared baking sheet. Bake about 3 hours. Sandwich meringues together with whipped cream to serve.

Makes about 8 meringues.

* What Jeanie hears Jock say is, "You'll have a cookie or am I wrong?"

Cookies

"Cookies" in Scotland are not what the English call biscuits and the Americans call cookies: they are sweet yeast buns. The particularly desirable "cream cookie" was a bun slit across and filled with cream, artificial or otherwise—impossible to eat daintily, like many favorites of the Glasgow cake stand. As with currant bread, they would normally have been bought from a baker for consumption at home, but today they are easy enough to make. If you have bread flour, combine it with plain in a ratio of 2 parts bread flour to 1 part plain. You can substitute honey for the glaze.

> 400 g (1 lb/4 cups) plain (all-purpose) flour
> pinch salt
> 75 g (3 oz/1/2 cup) plus 2 tablespoons caster (superfine) sugar
> 1 package easy blend (active dry) yeast
> 75 g (3 oz) butter or margarine
> 150 ml (5 fl oz) warm milk, or a little more
> 1 egg, beaten

Sift the flour into a bowl and stir in the salt, sugar, and yeast. Put in a very low oven to warm through. Combine the butter with the milk in a small saucepan and place over low heat until butter melts. Cool if necessary until it is just warm to the touch. Add to the flour mixture along with the egg. Mix and knead well. Put it back in the bowl, cover with plastic and leave in a warm place until it rises, more or less doubling in size. Turn it out and knead it again. Form into approximately 12 round buns and place, evenly spaced, on a lightly greased baking sheet. Cover loosely with a plastic bag and put back in the warm place until they rise again. Preheat oven to 220°C (425°F). Bake buns about 15 minutes. Combine the 2 tablespoons sugar with 2 tablespoons water and heat to boiling. Brush the glaze on the tops of the buns.

Makes about 12 "cookies."

Cream Cakes

A tea-room treat, this is basically a choux pastry bun. Choux pastry is really very easy to make, but the cakes have to be eaten fresh—they go soggy if kept for more than a few hours. This recipe is best made with strong bread flour, but ordinary flour can be used.

> 60 g (2$^{1}/_{2}$ oz/$^{1}/_{2}$ cup) strong white (bread) flour, sifted
> 2 teaspoons plus 1 tablespoon caster (superfine) sugar
> 50 g (2 oz) butter
> 2 eggs, beaten
> 225 ml (8 fl oz) double (heavy) cream
> icing (confectioners') sugar for dusting

Preheat oven to 200°C (400°F) and grease a baking sheet. Combine the flour and 2 teaspoons of the caster sugar. Put 150 ml (5 fl oz) cold water in a medium saucepan, add the butter in pieces, and heat. When the water is boiling, turn off the heat and quickly add the sugar-and-flour mixture, beating with a wooden spoon or an electric mixer until the mixture is smooth and shiny and comes away from the edge of the pan (this does not take long). Cool a little and then beat in the eggs a little at a time, mixing well to make a smooth paste. Spoon the mixture onto the prepared baking sheet in 6 mounds. Place a pan of water in the bottom of the oven and bake the cakes about 25 minutes, until they are crisp and dry. Cool on a rack.

Shortly before serving, partially slit the cakes from the side. Whip the cream with the 1 tablespoon caster sugar. Fill the cakes with the whipped cream and finish by dusting with icing sugar, or by icing them. Particularly good is coffee icing: add approximately 2 teaspoons strong coffee, little by little, to 100 g (4 oz/$^{3}/_{4}$ cup) icing (confectioners') sugar, stirring well, until the right consistency is reached.

Makes 6 cakes.

Coburg Cakes

These are individual spiced cakes topped with an almond, their name connecting them with Queen Victoria's husband, Albert, Prince of Saxe-Coburg. Traditionally the almond goes in the bottom of the muffin cup and the cake is then served upside down. If you wish, you can use a combination of syrup and treacle (molasses) instead of all syrup.

> 225 g (8 oz/2 cups) plain (all-purpose) flour
> 1 teaspoon bicarbonate of soda (baking soda)
> 1 teaspoon ground ginger
> $^1/_2$ teaspoon cinnamon
> $^1/_2$ teaspoon allspice
> 110 g (4 oz/$^2/_3$ cup) sugar
> 4 generous tablespoons golden syrup (light corn syrup)
> 50 g (2 oz) butter
> 2 eggs, beaten
> whole blanched almonds

Preheat oven to 180°C (350°F). Grease deep muffin tins or line them with paper baking cups. Sift the flour, soda, spices, and sugar together into a bowl and make a well in the middle. Combine the syrup and butter in a small saucepan and heat until butter melts. Pour into the dry ingredients. Add the eggs and beat well. Put an almond in the bottom of each muffin cup and half-fill with batter. Bake approximately 20 minutes.

Makes about 12 cakes.

Fruited Gingerbread

This is a good and easy-to-make cake that is best kept for a day before cutting.

220 g (8 oz/2 cups) self-raising (self-rising) flour
110 g (4 oz/3/4 cup) dark brown sugar
1/2 teaspoon bicarbonate of soda (baking soda)
1 teaspoon allspice
2^1/2 teaspoons ground ginger
100 g (4 oz/2/3 cup) sultana raisins
110 g (4 oz) butter or margarine
110 ml (5 fl oz/1/2 cup) golden syrup (light corn syrup)
2 tablespoons treacle (molasses) or golden syrup
110 ml (4 fl oz) milk
2 eggs, lightly beaten

Preheat oven to 170°C (325°F) and grease a 20 cm (8 inch) square baking pan. Mix the flour, sugar, soda, spices, and sultanas in a large bowl. Combine the butter, syrup, and treacle in a small saucepan and heat until butter melts. Allow to cool, then add the milk and eggs. Add this mixture to the dry ingredients and stir to make a sloppy batter. Pour batter into prepared pan and bake about 45 minutes.

Makes a 20 cm (8 inch) square cake.

Albert Cake

This is another cake with a good Victorian name. It is composed of a pastry base sprinkled with currants (sometimes jam as well), covered with a sponge cake mixture, and then iced. You can add decorations if you wish. The combination of pastry and cake is surprisingly good. Many Scottish bakers' cakes use a pastry base of some sort—partly perhaps to deal with the problem of sticking. It is easiest to make two of these at once. If you wish, you can use a ready-made crust.

Pastry Base
200 g (8 oz/2 cups) plain (all-purpose) flour
pinch salt
50 g (2 oz/4 tablespoons) margarine
50 g (2 oz/4 tablespoons) butter
1 tablespoon caster (superfine) sugar
4 tablespoons milk, approximately
100 g (4 oz/3/4 cup) currants

Cake
110 g(4 oz/1/2 cup) self-raising (self-rising) flour
1 teaspoon baking powder
110 g (4 oz /1/2 cup) soft margarine
110 g (4 oz/2/3 cup) caster (superfine) sugar
2 eggs
1/2 teaspoon vanilla essence (extract)
extra milk if needed
175 g (6 oz/1 1/4 cup) icing (confectioners') sugar, approximately

To make the pastry, in a food processor or with an electric mixer, combine the flour, salt, margarine, and butter. Add the sugar. Add milk little by little, mixing until it makes a dough that will stick together. Place in the refrigerator for 20 minutes. Divide the dough into 2 parts and roll each on a floured surface into a round to fit the bottom and sides of a 20 cm (8 inch) cake pan. Place the crusts in 2 cake pans and sprinkle currants over them (you can use jam or lemon curd, too, if you like).

Preheat the oven to 190°C (375°F).

To make the cake, sift the flour and baking powder into a bowl, add all the other ingredients (this method requires soft margarine), and mix well. Add a little milk if necessary to make a smooth batter. Divide the mixture between the 2 pans and bake about 20 minutes. Cool.

Sift the icing sugar and add hot water a little at a time, stirring well, until a spreadable consistency is reached. Spread the icing on the cakes.

Makes 2 cakes.

Dundee Cake

A traditional Scottish fruitcake, this keeps well.

200 g (8 oz/2 cups) plain (all-purpose) flour
$^1/_2$ teaspoon salt
1 teaspoon baking powder
150 g (6 oz) butter or margarine
150 g (6 oz/1 cup) caster (superfine) sugar
4 eggs, beaten
150 g (6 oz/1 cup) sultana raisins
75 g (3 oz/$^1/_2$ cup) raisins
75 g (3 oz/$^1/_2$ cup) currants
50 g (2 oz/$^1/_2$ cup) glacé cherries, rinsed and halved
50 g (2 oz/$^1/_2$ cup) candied peel
25 g (1 oz/$^1/_2$ cup) ground almonds
whole blanched almonds

Preheat oven to 170°C (325°F) and line a 20 cm (8 inch) diameter cake pan with baking parchment. Sift the flour, salt, and baking powder together. Cream the butter and sugar until pale and fluffy. Beat the eggs into the creamed mixture a little at a time, alternating with the flour mixture. Stir in the dried fruit and ground almonds. Pour the batter into the prepared pan. Arrange the almonds in a neat pattern of concentric circles on the top. Bake approximately 2 hours, covering the top loosely with foil if it becomes too dark. The cake is done when an inserted skewer comes out clean.

Makes a 20 cm (8 inch) diameter cake.

Sand Cake

"I can remember tea where the Mackintoshes had one special cake which they either got from Hubbard's or Skinner's (well-known Glasgow bakers). A cornflour cake—we used to call it a sand cake. It was a rather beautiful, pale, dryish cake. We liked it." This is Mary Newbery Sturrock, Fra and Jessie Newbery's daughter, recalling for Alistair Moffat girlhood teas with the Mackintoshes. I have been sent several different recipes for this cake. It is essentially a plain Madeira cake, using cornflour (cornstarch) or in some cases rice flour to give a particularly smooth texture. The following version works well. It can be flavored with grated lemon peel instead of vanilla if wished.

> 150 g (6 oz) butter
> 150 g (6 oz/1 cup) caster (superfine) sugar
> 3 eggs, beaten
> $^{1}/_{2}$ teaspoon vanilla essence (extract)
> 100 g (4 oz/1 cup) cornflour (cornstarch)
> 100 g (4 oz/1 cup) plain (all-purpose) flour
> 1 teaspoon baking powder
> 2–3 tablespoons milk

Preheat oven to 190°C (375°F) and grease a 20 cm (8 inch) diameter cake pan. Cream butter and sugar until pale and fluffy. Add eggs and vanilla a little at a time, beating well after each addition. Add the flours and baking powder and mix well. Add milk to make a rather soft mixture. Spread in prepared pan and bake until the top springs back when touched lightly and a skewer comes out clean—about 45 minutes.

Makes a 20 cm (8 inch) diameter cake.

The Mackintosh Trail in Glasgow

What is left of these wonderful Mackintosh tea rooms? Not as much as there should be. The tea rooms at Ingram Street survived the longest: they ran on after Miss Cranston's retirement under different management, but with respect for their special character, until 1950. Then came a dark period during which the interiors were effectively vandalized by a souvenir shop until what was left was finally stripped and stored before the demolition of the building in 1971.

From these piles of splintered wood Glasgow Museums brought back to life the white ladies' luncheon room, which was substantially reconstructed as the centerpiece of the successful Mackintosh exhibition held in Glasgow in 1996 and then in New York,

Chicago, and Los Angeles. Parts of the Chinese Room and the Cloister Room have also been reconstructed over recent years. However, the future home of these precious interiors—and there is the material for further reconstructions—is unclear at the time of writing. The obvious aspiration to house them permanently in Glasgow in a complete reconstruction depends on funding.

Meanwhile the Willow Tea Rooms on Sauchiehall Street are the main port of call for the visitor. In 1927 the adjacent department store, Daly's, broke through the common wall, but in 1980 the building underwent major restoration and the "Room de Luxe," which had survived relatively unscathed as the bridal wear department,

was reopened for teas and light lunches, with reproduction Mackintosh furniture of various kinds. The gallery has subsequently been brought back into tea-room use also.

Miss Cranston's Buchanan Street tea rooms have housed a bank since she left them, and the interiors were completely destroyed long ago. Next to the building is an establishment run by the present Willow Tea Rooms with decor derived from various elements of Mackintosh interiors.

The Argyle Street tea room building was sold to the shoe shop Manfield & Sons, Miss Cranston's tenant in the early days and still in business there until recently. The interiors, however, have vanished, and only fragments were salvaged.

Beginning with the Willow then, here is a list of the main Mackintosh sites in and around Glasgow that are open to the public. Many of them serve refreshments. For tea in the style of the traditional Glasgow tea rooms I would highly recommend Bradford's Tea Room, not far from the Willow, at 245 Sauchiehall Street—a quality family bakery with a pleasant tea room above, complete with cake stands and nice waitresses.

WILLOW TEA ROOMS

217 Sauchiehall Street
Glasgow G2 3EX
0141 332 0521

Opened in 1903. Became part of the adjacent department store in 1927. Largely restored to its original appearance in 1980. Teas and light lunches served in the Salon de Luxe and the gallery.

GLASGOW SCHOOL OF ART

167 Renfrew Street
Glasgow G3 6RQ
0141 353 4526

Mackintosh's architectural "masterwork," built in two phases, 1897–9 and 1907–9. A fully functioning and much-loved art school, with a considerable collection of original items such as furniture. Shop and guided tours.

SCOTLAND STREET SCHOOL

Museum of Education
225 Scotland Street
Glasgow G5 8QB
0141 429 1202

Striking school building on Glasgow's "South Side," 1903–6. Now houses the Museum of Education. Café.

THE MACKINTOSH HOUSE

Hunterian Art Gallery, University of Glasgow
Hillhead Street, Glasgow G12 8QQ
0141 330 5431

The main rooms and furnishings from the home made by Mackintosh and Margaret Macdonald in 1906. Reconstructed as part of the Hunterian Art Gallery, which houses the major collection of Mackintosh designs and watercolors—a must. Shop.

QUEEN'S CROSS CHURCH

870 Garscube Road
Glasgow G20 7EL
0141 946 6600

Mackintosh's only church actually executed, built 1897–9. Restored and used as headquarters by the Charles Rennie Mackintosh Society, which has worked since 1973 for recognition of Mackintosh and the preservation of his work. The society welcomes new members. Tea room and shop.

ART GALLERY AND MUSEUM

Kelvingrove, Glasgow G3 8AG
0141 287 2699

The "Glasgow 1900" gallery displays the Glasgow Style, showing the context of Mackintosh's work. Tea room and shop.

The Lighthouse
Scotland's Centre for Architecture,
Design and the City
56–76 Mitchell Street
Glasgow G1

*The old Glasgow Herald building, for which
Mackintosh designed a distinctive extension
in 1893, is being refurbished as a study and
interpretation center, to be opened May 1999.
Café and shop.*

The Hill House
Upper Colquhoun Street
Helensburgh G84 9AJ
01436 673900

*Some way outside Glasgow, but should be visited:
Mackintosh's domestic masterpiece, built for the
publisher Walter Blackie in 1902–4. Restored
and run by the National Trust for Scotland.
Tea room and shop.*

Ruchill Church Hall
Shakespeare Street
Glasgow G20 9PT

*Built 1898 and still much used by the congregation.
Café.*

Martyrs' Public School
11 Parson Street
Glasgow G4 OPX
0141 946 6600 (C. R. Mackintosh Society)

*Built 1895–98. Threatened with demolition in the
1970s, but survived and has been restored for use
as conservation studios and offices. Access by
arrangement with the C. R. Mackintosh Society.*

House for an Art Lover
Bellahouston Park, Dumbreck Road
Glasgow G41 5BW
0141 353 4770

*Not a "real" Mackintosh building, but a contro-
versial realization, completed in 1996, of his
1900–1 entry for a German publisher's competi-
tion to design "A House for an Art Lover."
Now occupied by the Glasgow School of Art.
Exhibition, café, shop.*

A Tea-room Chronology

1849 Kate Cranston born

1864 Margaret Macdonald born

1868 Charles Rennie Mackintosh born

1875 Stuart Cranston opens the first tea room
at 2 Queen Street

1878 Kate Cranston opens the Crown Tea Rooms
at 114 Argyle Street

1886 Kate Cranston opens tea rooms at
205 Ingram Street

1888 First Glasgow International Exhibition
Kate Cranston adds a lunch room
to Ingram Street

1892 Kate Cranston marries John Cochrane

1896 Stuart's group of tea rooms becomes
"Cranston's Tea Rooms, Ltd."
(Kate Cranston's business is known as
"Miss Cranston's Tea Rooms")

1897 Kate Cranston opens tea rooms at
91–3 Buchanan Street; Walton handles
interior design and furnishing, Mackintosh
contributes mural decorations

1899 Kate Cranston opens the expanded tea rooms
at 114 Argyle Street; Mackintosh designs the
furniture, Walton the decoration and fixtures

1900 Mackintosh marries Margaret Macdonald
Kate Cranston commissions the Mackintoshes
to do the interiors for a new ladies' luncheon
room and basement billiard room
at Ingram Street

1901 Second Glasgow International Exhibition:
Kate Cranston runs a "tea-house and
tea-terrace"

1903 Kate Cranston opens the Willow Tea Rooms
at 217 Sauchiehall Street; Mackintosh does all
design, inside and out

1904 Kate Cranston commissions Mackintosh to
redecorate and furnish her new home, Hous'hill

1906 Kate Cranston opens the basement Dutch
Kitchen tea room, designed by Mackintosh,
at her Argyle Street tea rooms

1907 Mackintosh designs the Oak Room and a new
billiard room at the Ingram Street tea rooms

1909	Mackintosh designs a ladies' rest room and the Oval Room at Ingram Street, and a card room at Hous'hill
1911	Scottish National Exhibition; Kate Cranston runs two tea rooms, The Red Lion and the White Cockade, the latter certainly designed by Mackintosh. Mackintosh redesigns two rooms at the Ingram Street tea rooms, creating the Chinese Room and the Cloister Room
1914	The Mackintoshes leave Glasgow
1917	Kate Cranston opens the Dug-Out at the Willow Tea Rooms, designed by Mackintosh. John Cochrane dies
1918–9	Kate Cranston sells the tea rooms and retires
1928	Charles Rennie Mackintosh dies
1933	Margaret Macdonald Mackintosh dies
1934	Kate Cranston dies

Checklist of Artworks and Furniture

Works are by Mackintosh unless otherwise indicated.

7

Design for stenciled mural decoration for
the Buchanan Street tea-rooms, 1896
Pencil and watercolor, 36.2 x 75.6 cm (14½ x 29¾ in.)
Hunterian Art Gallery, University of Glasgow, Mackintosh Collection, Glasgow

10

George Walton
Panel from a door in the lunch room, Argyle Street, 1899
Copper and leaded glass, with glass jewel insets
55.3 x 66.8 cm (21¾ x 26 in.)
Glasgow Museums and Art Galleries, Glasgow

11

High-backed chair for the Argyle Street tea rooms, 1899
Oak, stained dark, reupholstered with horsehair
136.8 x 50.5 x 46.2 cm (53⅞ x 19⅞ x 18³⁄₁₆ in.)
Glasgow School of Art, Glasgow

12

Design for high-backed chairs and table for the
Argyle Street tea rooms, 1898–9
Pencil and watercolor, 26.6 x 46.8 cm (10½ x 8⁷⁄₁₆ in.)
Hunterian Art Gallery, Glasgow School of Art, Glasgow

15

Decorative panel from the billiard room at
Ingram Street tea rooms, 1900
Stenciled and painted wood, 22.9 x 24.8 cm (9 x 9¾ in.)
Glasgow Museums and Art Galleries, Glasgow

16

Margaret Macdonald
The May Queen, 1900
Oil painted gesso, set with twine, glass beads, thread,
mother-of-pearl, and tin leaf
3 panels, each panel 158.8 x 152.4 cm
(62½ in. x 60 in.); total length 4.57 m (15 ft.)
Glasgow Museums and Art Galleries, Glasgow

17

Light fitting, 1900
Copper with painted aluminum finish, 24 x 37 x 37 cm
(9⁷⁄₁₆ x 14⁹⁄₁₆ x 14⁹⁄₁₆ in.)
Glasgow Museums and Art Galleries, Glasgow

18

Panels from screen in ladies' lunch room
at Ingram Street, 1900
Leaded plain and colored glass, each 34 x 38 cm (13⅜ x 15 in.)
Glasgow Museums and Art Galleries, Glasgow

19

The Wassail, 1900
Oil-painted gesso, set with twine, glass beads, thread,
mother-of-pearl, and tin leaf
3 panels, each panel 158.2 x 154 cm (62⅜ x 60⅝ in.);
total length 4.62 m (5 ft. 1⅞ in.)
Glasgow Museums and Art Galleries, Glasgow

21

Panel, 1900
from Ingram Street ladies' lunch room
Beaten lead with painted aluminum finish
Glasgow Museums and Art Galleries, Glasgow

24

Panel for rear dining room at the Willow Tea Rooms, 1903
Stenciled and painted linen,
160 x 40.2 cm (63 x 15¹³⁄₁₆ in.)
Hunterian Art Gallery, University of Glasgow,
Mackintosh Collection, Glasgow

25

Design for a plaster relief frieze for the
Willow Tea Rooms, 1903
Pencil and watercolor,
25.2 x 65.2 cm (9⁵⁄₁₆ x 17⁵⁄₁₆ in.)

Hunterian Art Gallery, University of Glasgow,
Mackintosh Collection, Glasgow

26

Doors for the Salon de Luxe, Willow Tea Rooms, 1903
Pine, painted white, with leaded-glass panels and
metal handles, 195.5 x 68.5 cm (77 x 27 in.) each
Morgan Grenfell Property Asset Management, Ltd.

29

High-backed chair for the Salon de Luxe,
Willow Tea Rooms, 1903
Oak, painted silver, with glass insets,
reupholstered with velvet
135 x 49.2 x 48 cm (53⅞ x 19⅜ x 18⅞ in.)
Hunterian Art Gallery, University of Glasgow,
Mackintosh Collection, Glasgow

30

Panel from the frieze, Salon de Luxe,
Willow Tea Rooms, 1903
Leaded, colored, and mirror glass,
79.7 x 26.7 cm (31⅜ x 9¼ in.)
Hunterian Art Gallery, University of Glasgow,
Mackintosh Collection, Glasgow

31

Margaret Macdonald

O Ye, All Ye That Walk in Willowwood, 1903

Painted gesso on hessian, set with glass beads,

164.5 x 58.4 cm (64¾ x 23 in.)

Private Collection; photograph courtesy of

Glasgow Museums and Art Galleries, Glasgow

33

Light fitting for the Oak Room, Ingram Street, 1907

Brass, 38.1 x 20 cm (15 x 7⅞ in.)

Glasgow Museums and Art Galleries, Glasgow

34

Margaret Macdonald

Design for a menu card for Miss Cranston's

White Cockade Tea Rooms, 1911

Gouache and watercolor on black paper,

21.8 x 31.6 cm (8⅝ x 12½ in.)

Hunterian Art Gallery, University of Glasgow, Mackintosh Collection, Glasgow

35

Section of paneling for the Chinese Room,

Ingram Street, 1911

Pine painted blue, with inset panels and niches made

from leaded mirror glass or plastic,

128.2 x 243.2 cm (50½ x 95¾ in.)

Glasgow Museums and Art Galleries, Glasgow

37

Section of wall paneling for the Cloister Room,

Ingram Street, 1911

Wood with light brown wash and painted blue decoration,

215.5 x 134 cm (84⅞ x 52¾ in.)

Glasgow Museums and Art Galleries, Glasgow

38

Design for the Dug-Out, Willow Tea Rooms:

West Wall of the Staircase and Vestibule, 1917

Pencil and watercolor, 40.2 x 76.5 cm

(15¹³⁄₁₆ x 30⅛ in.)

Glasgow School of Art, Glasgow

39

Settee for the Dug-Out, Willow Tea Rooms, 1917

Wood, repainted yellow, 79.5 x 137 x 70.4 cm

(31¼ x 53¹⁵⁄₁₆ x 27¾ in.)

Glasgow School of Art, Glasgow

40a and 40b

Jessie King

Menu designed for Miss Cranston, 1911–1917

Glasgow Museums and Art Galleries, Glasgow

Further Reading

Billcliffe, Roger. *Charles Rennie Mackintosh: The Complete Furniture, Furniture Drawings and Interior Designs.* 3d ed. London: John Murray, 1986.

Charles Rennie Mackintosh. Edited by Wendy Kaplan, with full bibliography. New York, London, and Paris: Glasgow Museums/Abbeville Press, 1996.

Crawford, Alan. *Charles Rennie Mackintosh.* London: Thames & Hudson, 1995.

Glasgow Girls. Edited by J. Burkhauser. Edinburgh: Canongate, 1990.

Kinchin, Perilla, and Juliet Kinchin. *Glasgow's Great Exhibitions: 1888, 1901, 1911, 1938, 1988.* Includes a contribution by Neil Baxter. Oxford: White Cockade Publishing, 1988.

Kinchin, Perilla. *Tea and Taste: The Glasgow Tea Rooms, 1875–1975.* 2d ed. Oxford: White Cockade Publishing, 1996.

Moffat, Alistair. *Remembering Charles Rennie Mackintosh: An Illustrated Biography.* Lanark: Colin Baxter, 1989.

Moon, Karen. *George Walton: Designer and Architect.* Oxford: White Cockade Publishing, 1993.

Quoted in the Text

Correspondence between the Mackintoshes and Hermann and Anna Muthesius. Hermann Muthesius Nachlass, Werkbund Archiv, Berlin. With grateful thanks to copyright holders for permission for quotation.

Lutyens, Edwin. *The Letters of Edwin Lutyens to his Wife Lady Emily.* Edited by C. Percy and J. Ridley. London: HarperCollins, 1985.

'Muir, J. H.' (pseudonym for James Bone, Archibald Hamilton Charteris, and Muirhead Bone). *Glasgow in 1901.* Glasgow and Edinburgh: William Hodge, 1901.

Munro, Neil. "Erchie in an Art Tea-room." In *Neil Munro, Erchie & Jimmy Swan.* Edited by Brian Osborne and Ronald Armstrong, 100–4. Edinburgh: Birlinn, 1993. Originally published under the name of Hugh Foulis in *The Evening News.*

White, Gleeson. "Some Glasgow Designers and Their Work," part I. *The Studio,* 11 (1897): 86–100.

Index